IMAGES
of America

VANISHING
PORTLAND

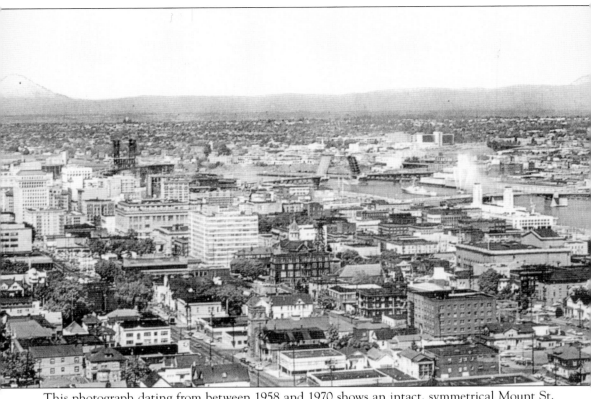

This photograph dating from between 1958 and 1970 shows an intact, symmetrical Mount St. Helens in the upper left and the top of Mount Adams in the upper right, both in the Cascade Mountains of southwest Washington. The tallest building in the left portion of the view is the Pacific Power building on Southwest Sixth Avenue. While the Pacific Power building remains, the large sign atop the building was removed in 1972. The lower building immediately to the south of the Pacific Power building is the Congress Hotel, which was torn down in 1977. Toward the right between Front Avenue and Harbor Drive are two white towers rising above the large *Oregon Journal* building, which was acquired by the city and demolished in 1970. Harbor Drive skirted the west bank of the Willamette River, until a planned expansion of Harbor Drive was redirected to remove the highway. Tom McCall Waterfront Park replaced Harbor Drive and the *Oregon Journal* building. This is a small sample of the many changes that have obscured much of the Portland that was once known. (Courtesy authors.)

ON THE COVER: This night view looking north down Broadway Street shows Portland's theater district in its long-lost heyday. The 3,036-seat Paramount Theater opened as the Portland Theater in 1928, changed to the Paramount Theater in 1930, was eventually purchased by the City of Portland, and in 1984 became the Arlene Schnitzer Concert Hall. The 1,458-seat Mayfair Theater originally was opened as the Heilig Theater, operated as the Mayfair Theater in the 1930s and 1940s, changed to the Fox Theater in the early 1950s, and was demolished in 1997 to make room for the Fox Tower. In 1913, the 1,750-seat Orpheum Theater opened as the Empress Theater, operated as the Hippodrome Theater from 1917 to 1925, was the Pantages Theater from 1927 to 1929, and became the Orpheum Theater in 1929; demolished in 1954, it was eventually replaced by a Nordstrom store. The Liberty Theater originally opened in 1916 as the T&D Theater, operated as the Liberty Theater until 1960, and was demolished in 2004. The 1,832-seat Broadway Theater was opened in 1926 and demolished in 1988. (Courtesy Mark Moore.)

IMAGES
of America

VANISHING PORTLAND

Ray and Jeanna Bottenberg

ARCADIA
PUBLISHING

Published by Arcadia Publishing
Charleston SC, Chicago IL, Portsmouth NH, San Francisco CA

Printed in the United States of America

Library of Congress Catalog Card Number: 2007943432

For all general information contact Arcadia Publishing at:
Telephone 843-853-2070
Fax 843-853-0044
E-mail sales@arcadiapublishing.com
For customer service and orders:
Toll-Free 1-888-313-2665

Visit us on the Internet at www.arcadiapublishing.com

For Jeanna's grandma Marjorie Sanders, who moved out of Vanport City with her late husband, Melvin Johnson, and daughter Melva about one week before the disastrous 1948 Vanport flood.

CONTENTS

ACKNOWLEDGMENTS

We wish to thank Robert W. Hadlow, Ph.D., of the Oregon Department of Transportation for providing much information and for reviewing the nearly completed book. We also wish to thank the City of Portland's Stanley Parr Archives and Records Center, the Multnomah County Library, the Oregon Department of Transportation, the Oregon State Archives, the Oregon State University Archives, the Nelson family archive, the Portland General Electric Company, the James G. Murphy Company, Donald R. Nelson, Mark Moore, Esther Norman, Dusty Schmidt, Ken Goudy, Ronald Atseff, Donley Bottenberg, Stephen Kenney Jr., Michael Fairley, Linda and Dale Renk, Karin Johnson, and Andi Sheldon for making photographs available for use in this volume.

And we would also like to thank the following individuals for the guidance and assistance they have provided that made this volume possible: Brian Johnson of the City of Portland's Stanley Parr Archives and Records Center; Pat Solomon and Christopher Leedham of the Oregon Department of Transportation; David Wendell, Todd Shaffer, Andrew Needham, and Tim Backer of the Oregon State Archives; Karl McCreary, Douglas Schulte, and Lawrence A. Landis of the Oregon State University Archives; Mark Fryburg of Portland General Electric Company; Julie Murphy-Rice of the James G. Murphy Company; Mel and Denise Thayer; Donald R. Nelson; Ken Goudy; and Julie Albright, our editor at Arcadia Publishing.

INTRODUCTION

Portland has been a city of change ever since the 1845 coin toss that gave founder Francis Pettygrove the right to name the city after Portland, Maine. Had Pettygrove lost, cofounder Asa Lovejoy would have named the city after Boston, Massachusetts.

Portland soon became Oregon's largest city and a major shipping point for the lumber, wheat, and other commodities of the Pacific Northwest. As the state's largest city, it also became a hotbed of vice and corruption, having the state's largest concentration of drinking establishments and houses of prostitution. In 1912, a vice report claimed that 25 percent of diseases treated in Portland were venereal and that there were 400 "immoral" places within the city, including mainly brothels but also certain hotels and rooming houses. A similar 1913 report by the Bureau of Municipal Research, a New York consultant, noted problems with corruption. The City of Portland was corrupt enough that the state legislature stripped the city of the right to build or own bridges after bridge contracts were awarded to build bridges for amounts approaching 50 percent higher than the lowest bid. A network of sailors' boardinghouses, bars, underground tunnels, and trapdoors were used by "crimps" who drugged men and forged the men's signatures on ships' articles, collecting a fee and often collecting advances against their victims' pay. The men thus "shanghaied" woke up signed on as sailors for a voyage, and until the Seamen's Act of 1915, it was illegal for sailors to leave a ship until their voyage was completed. Portland's most notorious crimp was Joseph "Bunco" Kelley, who reportedly once stole a wooden Indian from the front of Wildman's Cigar Store at the corner of Front Avenue and Glisan Street, passing it off as a drunken sailor for a $50 fee. The wooden Indian was returned to Wildman's after getting caught in a Columbia River fisherman's net. Known for "Kelly's Knock-Out Drops," Kelly also reputedly shanghaied prostitutes and dressed them as men, and he collected a $720 fee for delivering 24 "drunken" sailors who had accidentally consumed stolen formaldehyde and were deceased. Crimping came to an end late in the 1920s as a result of both the Seamen's Act of 1915 and the replacement of most sailing vessels with labor-saving steam vessels.

As the Willamette Valley's pioneers became established, they began producing wheat as a cash crop, and Portland became a shipping point for the crop. Starting with a cargo of wheat on the *Sally Brown*, bound for Liverpool, England, in the late 1860s, Portland became an important wheat shipping port. Flour milling also became an important business in Portland. Wheat shipping remains an important business in Portland, with over eight million short tons of soft white wheat shipped in 1981. The meatpacking industry also developed on a massive scale in Portland. In 1905, Swift and Company purchased 3,400 acres in the Kenton area, near the Northern Pacific Railroad, and started the Portland Union Stockyards. Swift also built a massive meatpacking operation, which operated until the 1950s. Armour and Oscar Meyer both established large packing operations, which closed after Swift. The Union Stockyards, which included a first-class hotel and restaurant, closed in 1988. Portland also had wool processing operations, the largest being Portland Woolen

Mills, which closed in approximately the 1960s, and the Pendleton Woolen Mills, which moved to Portland in 1955 and are still in operation.

Early in Portland's history, lumber mills were established, using Portland as a shipping point to export their products. During the 20th century, large lumber companies concentrated in Portland. Willamette Industries, founded in Dallas, Oregon, in 1906, maintained a corporate presence in Portland continuously, starting as early as 1909. Georgia-Pacific Corporation moved its corporate headquarters to Portland in 1954. During the middle 20th century, the pulp and paper industry became increasingly important in the area and fit well with the established timber companies. The historic Pope and Talbot, Inc., moved its corporate headquarters to Portland in approximately 1946. Louisiana-Pacific Corporation, formed by court order from a portion of Georgia-Pacific Corporation, was founded in Portland in 1973. Increasing timber production in the southeastern United States, logging cutbacks because of the Endangered Species Act protection of the northern spotted owl, and industry consolidation have taken their toll on the West Coast timber industry. In 1982, Georgia-Pacific Corporation moved its headquarters to Atlanta, Georgia. In 2002, Willamette Industries was purchased by Federal Way, Washington–based competitor Weyerhauser in a hostile takeover. In 2004, Louisiana-Pacific Corporation moved its headquarters to Nashville, Tennessee.

In 1905, Portland hosted the Lewis and Clark Centennial Exposition, celebrating the explorers sent West by Pres. Thomas Jefferson to examine the Louisiana Purchase and what later became the Oregon Territory. The exposition's organizers hoped to promote Portland as the commercial hub of the Pacific Northwest. Total attendance at the exposition was 2,554,848 between its opening June 1, 1905, and closing October 15, 1905. After the exposition, most of the buildings were removed, except for the Forestry Building, which burned in 1964. The Montgomery Ward and Company building was built on the site in 1922 and survives today as Montgomery Park.

Shipbuilding became an important industry in Portland in the era of wooden ships, taking advantage of the city's port location and nearby abundant timber supplies. Many wooden ships were built in Portland during World War I. During World War II, Portland became a shipbuilding power as industrialist Henry J. Kaiser established Oregon Shipbuilding Corporation at St. Johns with 11 shipways to build Liberty ships in Portland, then a yard with 12 shipways in nearby Vancouver, Washington, and finally a yard with eight shipways on Swan Island to build T2 oil tankers. Near the end of World War II in 1945, Oregon Shipbuilding had produced 330 Liberty ships, 48 Victory ships, and 30 Attack Transports; the Kaiser Vancouver yard had produced 10 Liberty ships, 30 landing ships, 50 aircraft carriers, and 31 AP5 troop transports; and the Swan Island yard had produced 134 T2 oil tankers. Together these shipyards employed approximately 90,000 workers, of which between 25 and 35 percent were women. These shipyards set numerous records both for speed of production and for deliveries of completed ships, the most notable being a demonstration of how prefabricated components made it possible to produce a completed hull in 71.5 hours. The accomplishments of these shipyards contributed in no small way to the Allied victory in World War II.

At the conclusion of World War II, the demand for ships collapsed and much of Portland's shipbuilding industry disappeared. The town of Vanport City, located between the Columbia Slough and the Columbia River near present-day Delta Park, had been hastily built to house shipyard workers during the wartime boom. Costing $26 million, Vanport was billed as the nation's single largest housing project and the second largest city in Oregon, with 40,000 residents occupying 9,914 homes. Vanport's first residents moved in on December 12, 1942. Vanport included schools, fire halls, churches, stores, and a theater. At about 4:17 p.m. on May 30, 1948, a section of the dike that protected Vanport failed during a massive flood. The 10-foot-high wall of water and the 35- to 40-minute-long inundation that followed destroyed the town of Vanport. Sixteen people died and 18,500 lost their homes, and the town was not rebuilt. Present-day Portland International Raceway occupies a portion of Vanport's area.

Corruption had not been entirely eradicated, and by 1948, the Portland police were reportedly collecting $60,000 per month in protection payments from prostitution and gambling operations,

with much of the money reportedly going to Mayor Earl Riley. Reports of this situation became public and enabled Dorothy McCullough Lee to be elected mayor, promising clean government and even-handed law enforcement. However, the corruption was so entrenched that most of the payoffs continued outside the view of the mayor. The problem continued after the Lee administration until 1957, when most of the crime bosses were indicted and many were convicted and sent to prison.

In 1959, the Pacific International Livestock Exposition grounds, used in 1942 as an assembly center for persons of Japanese descent who were relocated to internment camps during World War II, hosted the Oregon Centennial Exposition. The exposition celebrated Oregon's history and future with many exhibits, including a home of the future and a General Motors concept car, and a staggering list of entertainers, including Hank Snow, Harry Belafonte, Art Linkletter, Roy Rogers, Dale Evans, the Sons of the Pioneers, the Ice Capades, the International Water Follies, and the Japanese Takarazuka Kabuki Dancers.

Since the 1950s, a number of landmarks have been demolished to make way for improvements like "modern" parking garages and other buildings. The Portland Hotel fell to the wrecking ball in 1951 for Meier and Frank's new parking garage. A massive, ambitious project undertaken by the Portland Development Commission rebuilt the South Auditorium area, approximately 135 acres bounded by Southwest Market Street, Harbor Drive, Arthur Street, and Southwest Fourth Avenue. Between 1958 and 1966, at least 349 parcels of real estate were condemned, 1,573 residents were relocated including 336 families and 289 businesses, and 445 buildings were demolished. After the removal of the area's predominantly older Jewish and Italian immigrant residents and numerous cast-iron buildings, the area was rebuilt with a mixture of high-rise apartments and offices, hotels, stores, parks, and malls. The redeveloped area is now known as Portland Center or New Town. Similar projects since 1959 have altered the Albina neighborhood, the Portland State College (now Portland State University) area, the Emanuel Hospital area, the downtown waterfront area, the Northwest Front Avenue area, the South Park Blocks area, the St. Johns area, the central east side, the Airport Way area, the Oregon Convention Center area, the River District area, the Lents Town Center area, the North Macadam area, the Gateway area, and the Interstate area.

In the late 1960s, a proposal to widen Harbor Drive along the west bank of the Willamette River prompted widespread protest against development that would further limit access to the waterfront. Eventually Harbor Drive and all of the buildings between Harbor Drive and Front Avenue were removed to create the Tom McCall Waterfront Park.

In the 1990s, the pace of change increased yet again as globalization of business and industry continued, waves of mergers and acquisitions eliminated well-known businesses, and the "big-box" merchandising trend forced many old-line retailers out of business. The most well-known example of this is the acquisition of the Meier and Frank department store chain by Federated Department Stores, also known as Macy's.

So change is a common theme throughout Portland's history. Portland's icons include buildings of all types, retail stores, restaurants, bars, nightclubs, theaters, newspapers, sports teams, sports personalities, musicians, amusement parks, banks, hotels, bridges, television and radio personalities, and numerous companies and their products. This volume illustrates selected examples of these changes. The actual number of these icons that have vanished appears to be truly quite large. In fact, the main difficulty in putting this volume together has been deciding which of these many vanished icons could be included and which could not. We hope that this volume will bring back many wonderful memories for Portlanders of all ages old enough to remember.

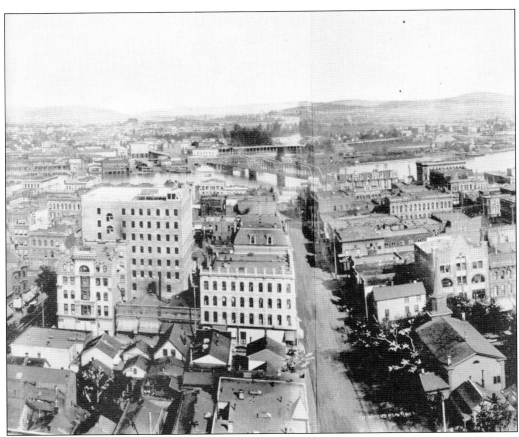

As an illustration of the changes in Portland over the years, this 1892 image looking toward Mount Hood in the east shows a lot. Portland's first Willamette River bridge, the wooden Morrison Street Bridge that was replaced in 1905 and again in 1958, is visible crossing the Willamette River near the center of the scene, and a railroad trestle is visible on the east bank of the river. A portion of Portland's busy harbor is visible along the banks of the river. The view shows some large cast-iron buildings, some brick buildings, and many wooden buildings not more than a few stories tall. Single-family houses have not been common in this area for approximately a century. In the decades that followed, more wooden buildings were replaced with taller and larger brick and cast-iron buildings, and the streets were improved. In turn, many of the improvements of the late 1800s and early 1900s were razed between the 1950s and the present to make way for taller modern buildings, freeways, and parks. (Courtesy City of Portland Archives.)

One

STORES

Portland's retail stores have seen their share of change over the years, with a number of beloved local institutions either going out of business or being taken over by large national chains. For example, Meier and Frank operated for 149 years in Portland before being renamed Macy's, and the Portland-based Sprouse-Reitz dime store chain thrived for most of its 84 years before closing, unable to find a buyer.

On a smaller scale, a vast number of neighborhood grocery stores also thrived in Portland until the 1950s and 1960s, largely to be replaced by national chain convenience stores.

Many Portlanders have fond memories of Christmas shopping or visiting Santa Claus or the Cinnamon Bear at the department stores shown in this chapter.

The shift in ownership and control of stores from local stores or regional chains to national chains might provide lower prices for consumers, but the price is the loss of an important part of a city's identity.

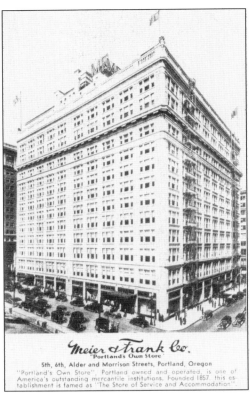

This photograph shows Portland's Meier and Frank department store after an expansion completed in 1932. The store occupied an entire city block between Southwest Fifth and Sixth Avenues and Alder and Morrison Streets and housed over 100 individual departments. With 15 stories above street level and four below, the building contained over 14.5 acres of floor space. (Courtesy authors.)

Meier & Frank Co.
"Portland's Own Store"
5th, 6th, Alder and Morrison Streets, Portland, Oregon
"Portland's Own Store", Portland owned and operated, is one of America's outstanding mercantile institutions. Founded 1857, this establishment is famed as "The Store of Service and Accommodation".

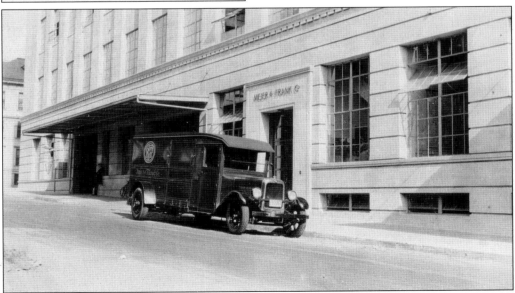

This scene shows a Meier and Frank delivery truck at the loading dock of the Meier and Frank store. Aaron Meier started the business in 1857 in Portland, taking Emil Frank as a partner by 1873. Their department store has been a Portland fixture ever since. In 1966, ownership passed to the May Company, which was purchased by Federated Stores in 2005. In 2006, Macy's signs were installed. (Courtesy authors.)

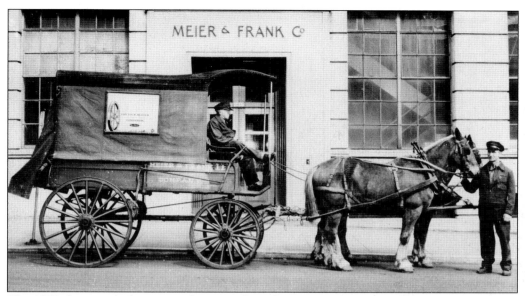

This 1957 photograph shows one of Meier and Frank's famous green horse-drawn delivery vehicles at the loading dock of the store. The wagon shown was last used in 1916 and brought out of storage for use in Meier and Frank's centennial festivities in 1957. Legend holds that Meier and Frank would deliver even the smallest of orders for their esteemed customers, including sewing needles. (Courtesy Mark Moore.)

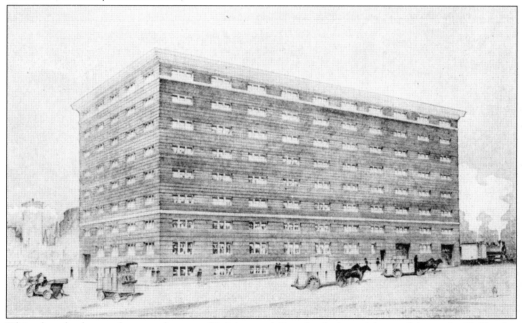

This sketch shows the warehouse of Meier and Frank, designed by architect A. E. Doyle. Affectionately known as "Murphy and Finnegan" in early years even by founder Aaron Meier, Meier and Frank billed itself as "Portland's Own Store." Oregon's pioneers held a strong disdain for "eastern money," and for many Portlanders, this disdain survived through most if not all of the 20th century. (Courtesy Multnomah County Library.)

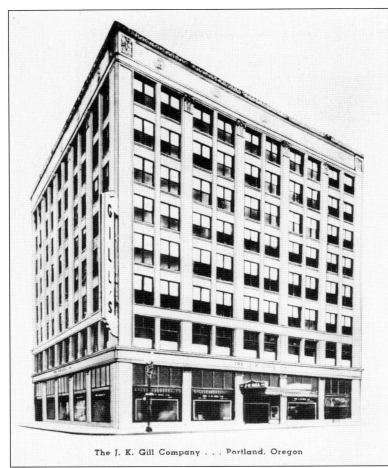

The J. K. Gill Company . . . Portland, Oregon

This undated view shows the J. K. Gill Company store at Southwest Fifth Avenue and Stark Street. Joseph K. Gill started in business as a bookseller in Salem, Oregon, in 1867, moved to Portland in 1870, and began what became J. K. Gill and Company, a stationery and book retailer that also published books and maps. J. K. Gill closed in January 1999, citing competition from larger stores. (Courtesy authors.)

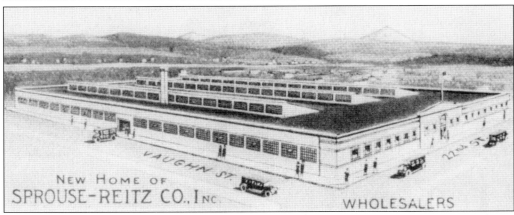

This view shows the headquarters of the Portland-based Sprouse-Reitz variety stores at Northwest Twenty-second Avenue and Vaughn Street, from 1927 until 1971. Sprouse-Reitz had moved its corporate headquarters to Portland in 1919. In 1971, Sprouse-Reitz moved to a building at Southwest Thirteenth Avenue and Morrison Street, leasing the first floor to First Interstate (formerly First National) Bank. (Courtesy Multnomah County Library.)

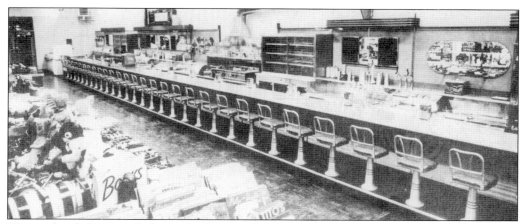

This undated photograph shows the fountain lunch counter in a Sprouse-Reitz store. The chain experimented with the lunch counters from 1947 through 1954 but removed them to use the space for more profitable merchandising. Founded in 1909 in Tacoma, Washington, by Robert Allen Sprouse, John Allen Sprouse, and Fred L. Reitz, Sprouse-Reitz was a variety/general merchandise retailer with stores in 11 states. (Courtesy Multnomah County Library.)

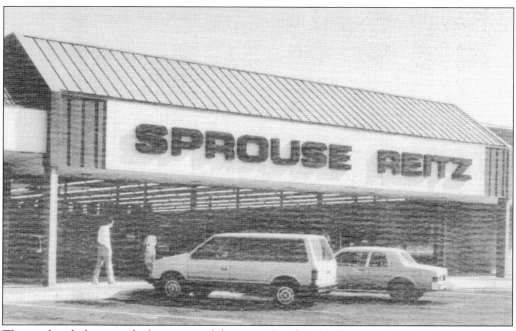

This undated photograph shows one of the many Pacific Northwest stores of Sprouse-Reitz. At its peak, Sprouse-Reitz had nearly 400 stores in the Western states. The dime store fell on hard times by the early 1990s, attempting to revitalize sales by renaming itself Sprouse! in 1991. After failing to find a buyer for its remaining 84 stores, Sprouse! decided to liquidate in December 1993. (Courtesy Multnomah County Library.)

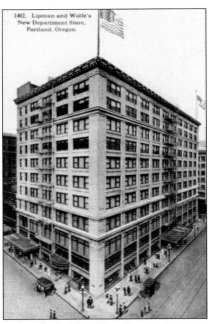

This 1923 photograph shows Lipman and Wolfe's Department Store, designed by architects Doyle and Patterson and built in 1912. Founded by Solomon Lipman in Sacramento, California, in 1850, the company opened a Portland branch in 1880. In 1980, Marshall Fields bought Lipman's, operating it under their Frederick and Nelson name until it closed in 1986. (Courtesy City of Portland Archives.)

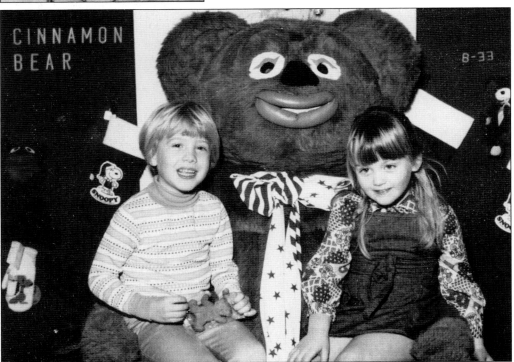

The Cinnamon Bear visited Lipman's at Christmastime. Shown in this 1975 photograph with youngsters John DeRaeve at left and Nicole Sheldon at right, the Cinnamon Bear gave the children cinnamon cookies shaped like bears. In November 1937, the popular Cinnamon Bear radio program started, and Lipman's immediately made arrangements for the bear to greet children at their store as Santa's right-hand man. (Courtesy Andi Sheldon.)

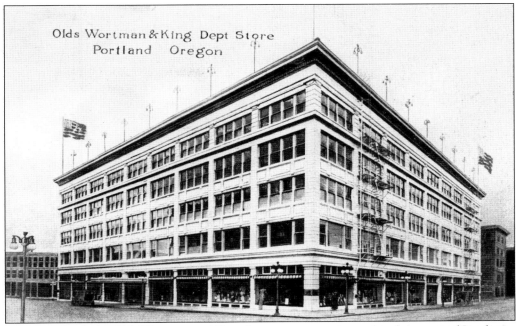

This view shows the Olds Wortman and King department store, located at the corner of Southwest Tenth Avenue and Morrison Street. Established in 1851 by W. P. Olds and S. W. King, who soon added H. C. Wortman as a partner, the company built this structure in 1910 occupying an entire block. In 1974, the department store closed and the building was renovated, today housing the Galleria and Western Culinary Institute. (Courtesy authors.)

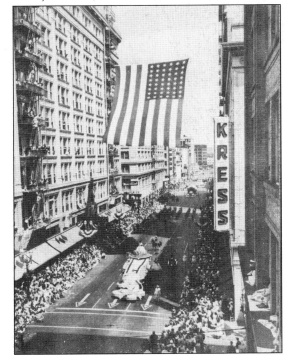

This Rose Festival Parade scene shows Portland's Kress department store. The chain of five-and-dime stores was founded by S. H. Kress in Nanticoke, Pennsylvania, in 1896 and grew nationwide. In 1964, ownership of the chain passed to Genesco, Inc., and by 1980 or 1981, the chain was liquidated. (Courtesy authors.)

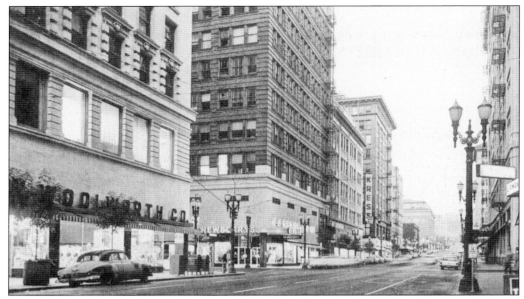

This undated photograph shows Portland's Woolworth store. Nearby the Kress store and the Newberry store are visible, and across the street, Lipman and Wolfe is also visible. Portland's Woolworth store was founded in 1905 or earlier by E. P. Charlton, who merged his 52 stores into F. W. Woolworth Company in 1912 in a $65-million deal involving six companies. (Courtesy Mark Moore.)

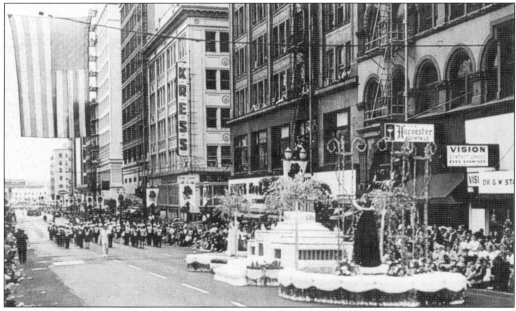

This undated Rose Festival photograph shows Portland's Newberry store, with the Kress store, the Fred Meyer store, and the Harvester Cocktails also visible. The J. J. Newberry Company was founded in Stroudsburg, Pennsylvania, in 1911 and established its downtown Portland store in 1927. The downtown store closed in 1996, while the Lloyd Center store lingered until about 1997, when a wave of some 300 Newberry stores closed nationwide. (Courtesy Mark Moore.)

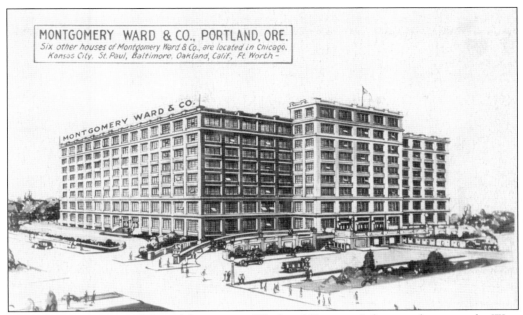

This advertising postcard shows Montgomery Ward and Company's first warehouse on the West Coast, designed by Montgomery Ward employee W. H. McCaulley and built of reinforced concrete in 1922. The store, which housed nine stories of merchandise, was expanded with an added wing in 1936. While the building has been renovated, Montgomery Ward succumbed to bankruptcy in 2001. (Courtesy Linda and Dale Renk.)

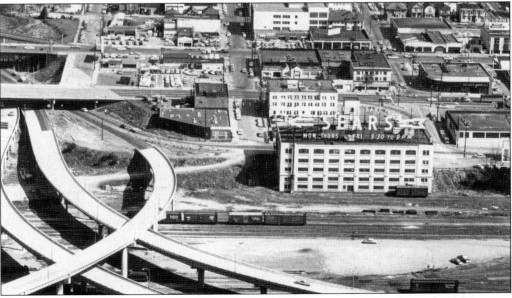

This May 1964 aerial view shows Sears, Roebuck, and Company at 524 Northeast Grand Avenue. This was the main Sears store in Portland for many years. While Sears remains in business in the Portland area, by about 1983, the retail market had changed and Sears closed this longtime, familiar store. (Courtesy City of Portland Archives.)

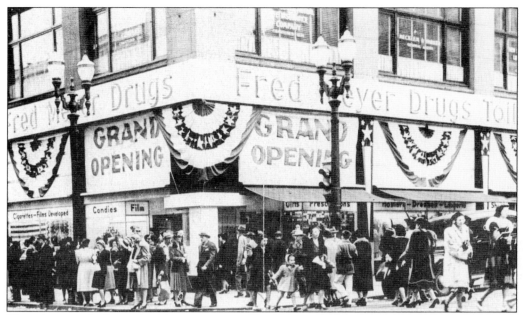

This photograph shows the Morrison store of Fred Meyer Drug at its 1942 grand opening about one block away from Fred Meyer's original 1922 store. Lack of parking and floor space eventually made operations difficult. The store was demolished in 1984 and replaced with a store at Southwest Sixth Avenue and Alder Street. Fred Meyer was acquired by the national chain Kroger in 1999. (Courtesy Multnomah County Library.)

This early-1970s aerial photograph shows one of Portland's many Safeway grocery stores, this one located just east of Interstate 5 at Jantzen Beach near the Waddle's restaurant, visible at the right. An up-to-date, much larger Safeway store is now located on the site. (Courtesy Oregon State Archives.)

This photograph shows Portland's PayLess Drug Store at the corner of Broadway and Washington Street. The first PayLess store was opened in LaGrande, Oregon, in 1939, and eight others were opened in Oregon, Washington, and Idaho by 1945. The Wilsonville-based PayLess was a popular general merchandise store in the region for many decades, but in 1996, the chain was acquired by Rite Aid, eliminating the PayLess name. (Courtesy Mark Moore.)

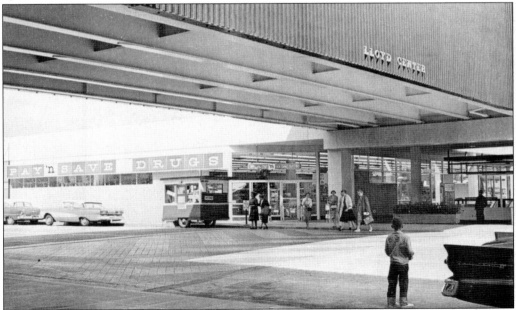

This photograph shows the Pay 'n Save drugstore at the Lloyd Center. The Seattle, Washington–based drugstore founded in 1941 by M. Lamont Bean was acquired by PayLess Drug Stores in 1992, ending the use of the Pay 'n Save name. PayLess Drug Stores was in turn purchased by the East Coast's largest drugstore chain, Rite Aid, in 1996. (Courtesy authors.)

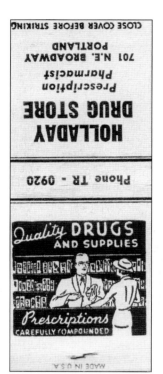

This matchbook cover advertises the Holladay Drug Store, located at 701 Northeast Broadway Street. A Rexall outlet, Holladay offered a lunch counter and soda fountain. A 1940 advertisement claims "drugs & sundries, prescriptions, fountain service, we are never undersold." Operated by Henry G. Dahlgren and partners, the store evidently closed during the 1960s. (Courtesy authors.)

This 1946 photograph shows the City Hall Pharmacy, located at the corner of Southwest Jefferson Street and Southwest Fifth Avenue. The City Hall Pharmacy was operated by Ralph A. Watson. A 1937 Chevrolet panel delivery vehicle approaches the intersection, followed by a 1946 or 1947 Studebaker and an International Harvester army truck converted for civilian use, and billboards across the street advertise Roma Wines and Langendorf Bread. (Courtesy City of Portland Archives.)

This undated photograph shows the Fifth Avenue Shop, which was located at 711 Southwest Tenth Avenue. The Fifth Avenue Shop was in operation from the 1930s into the early 1980s. The store's operator was listed as Mrs. Charlotte B. Thompson during 1940 and as Mrs. Charlotte B. Corbett by 1970. (Courtesy Multnomah County Library.)

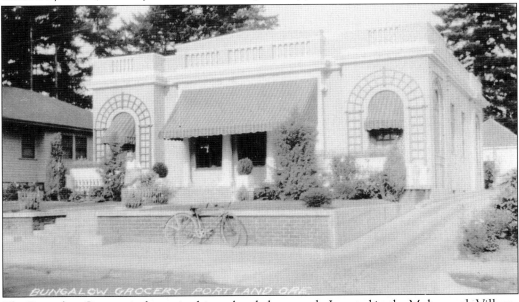

The Bungalow Grocery is shown in this undated photograph. Located in the Multnomah Village neighborhood on Southwest Thirty-fifth Avenue, the Thomas Bungalow Grocery was built in 1913. In early years, a neighborhood post office was located inside Bungalow Grocery. No longer a grocery store, the building currently houses Marco's Café and Espresso Bar and has been a Masonic Lodge and dance hall. (Courtesy authors.)

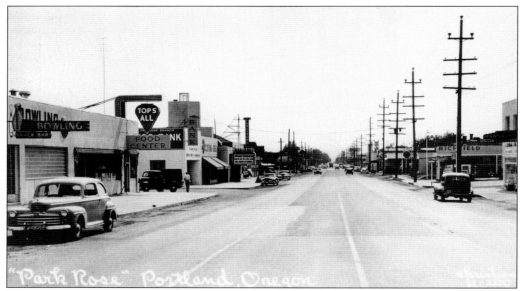

This 1940s photograph shows a street scene in the Park Rose neighborhood, with its Tops All Food Center. Also shown are a bowling alley, a furniture store, a bank, a clothing store, Lou's Tavern, a Richfield gasoline station, a Shell gasoline station, and the Parkrose Theater. The automobile at left is a 1947 or 1948 Ford. (Courtesy City of Portland Archives.)

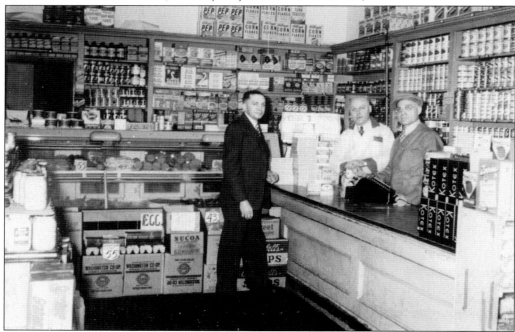

This photograph shows, from left to right, an unidentified customer, Sam Atseff, and Andy Atseff inside the Atseff Brothers Grocery on Larrabee Street. The brothers operated their store from 1918 or 1919 until 1957, moving less than one block in 1949. Typical of neighborhood stores that have been replaced by today's convenience stores, the Atseff store was razed in 1958 and replaced with a parking lot for the Coliseum. (Courtesy Ronald Atseff.)

This 1944 photograph shows the Peninsula Grocery, located at the corner of North Lombard Street and Fiske Avenue. Apparently also known as Peninsula Produce Company, the store was in business during the 1940s and lasted until about 1967. From the late 1940s until 1967, Peninsula was operated by Jason Ito and S. Kimura. (Courtesy City of Portland Archives.)

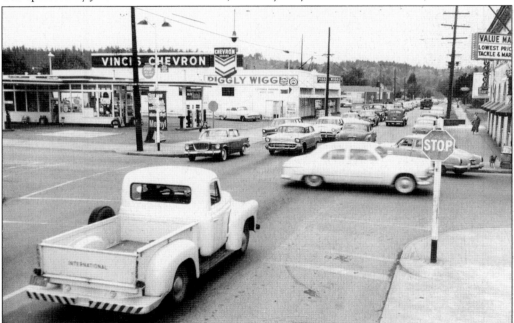

This May 3, 1960, photograph taken at the intersection of Southeast Thirteenth Avenue and Tacoma Street shows a Piggly Wiggly grocery store and a Chevron gasoline station. From the 1930s into the 1960s, other Piggly Wiggly stores were located on West Burnside Street, Southeast Eighty-second Avenue, Southeast Hawthorne Boulevard, North Lombard Street, Southeast McLoughlin Boulevard, Northeast Sandy Boulevard, Southeast Seventeenth Avenue, and Northwest Twenty-third Avenue. (Courtesy City of Portland Archives.)

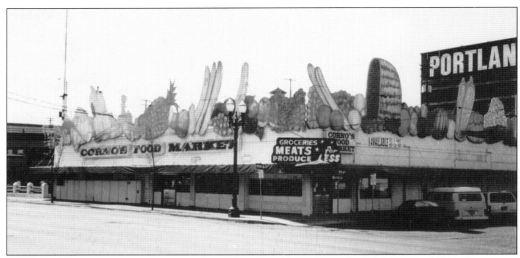

This 2005 photograph shows the former Corno's Food Market, which began in 1951 at the corner of Southeast Union Avenue and Alder Street as Corno and Son. Originally a produce stand, Corno's expanded many times over the years under the direction of the Corno family. The store closed in approximately 1995, the city acquired the block, and the building was torn down in approximately 2005. (Courtesy Donald R. Nelson.)

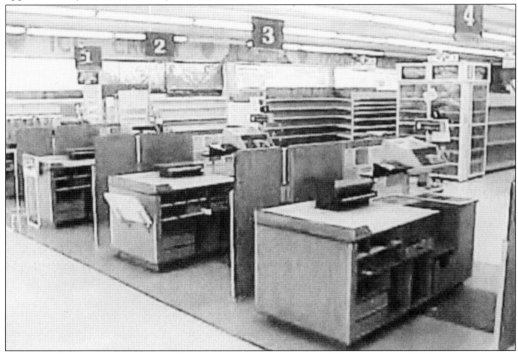

This 1999 photograph shows the interior of a Kienow's Food Stores during liquidation. Started by Dan Henry Kienow in 1908, Kienow's—"Not Your Ordinary Grocery Store"—was sold to Western Investment Trust of Emoryville, California, in 1998, which immediately liquidated eight stores. The King City and Oak Grove stores remained open, with the Oak Grove store liquidating in 2000 and the King City store later. (Courtesy James G. Murphy Company.)

Two

RESTAURANTS, BARS, AND NIGHTCLUBS

Probably some of the fondest memories of Portlanders include cruising to the drive-in restaurants of the 1950s and 1960s. Some of the more popular drive-ins include the Tik Tok, Waddle's Coffee Shop, Yaw's Top Notch, and Bart's. Young people met at these places to enjoy hamburgers, French fries, milk shakes or sodas, their cars, and their friends. Today there are national hamburger chains with drive-up windows without much of the appeal of the old drive-ins.

Portland's past includes the "World's longest bar" at Erickson's Saloon; the largest restaurant in the state of Oregon, the Jolly Joan; and a club owned by an illegal gambling operator, the Pago Pago.

This chapter shows a number of Portland's vanished restaurants, bars, and nightclubs. As these local establishments have vanished and been replaced by national chains, more of Portland's identity has been lost.

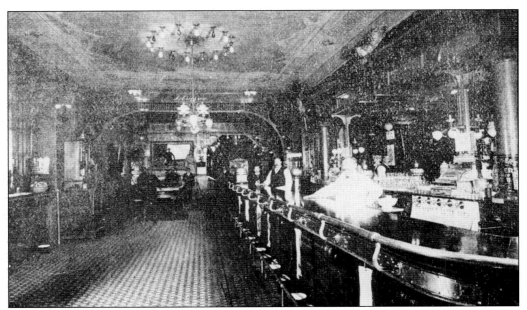

This 1899 photograph shows the interior of Erickson's Saloon on Burnside Street between Second and Third Avenues. Started in the early 1880s by August "Gus" Erickson, it was legendary for its 684-foot bar, a free smorgasbord lunch with a 5¢ beer, and serving on a barge during the 1894 flood. Reports indicate that prostitution flourished upstairs. Currently the site houses the Barracuda Club. (Courtesy Nelson family archives.)

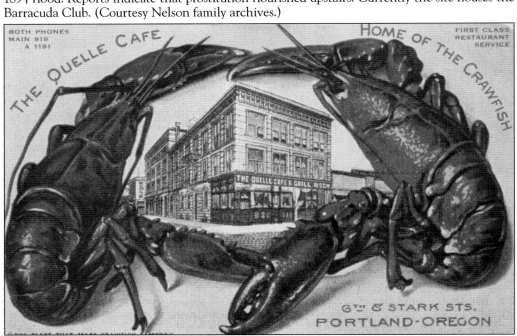

This advertising postcard shows the Quelle Café, located at the corner of Southwest Sixth Avenue and Stark Street. Owned by Fred Sechtem and J. E. Falt, the Quelle's specialty was crawfish. From 1901 through 1906, the Quelle Saloon occupied the same address, owned by Sechtem and Schlenk. The saloon and café both appear to have closed by 1910. (Courtesy Dusty Schmidt.)

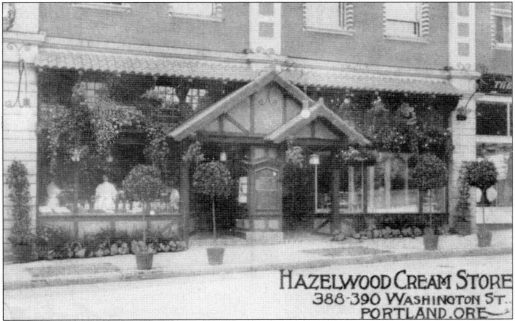

This early photograph shows Portland's Hazelwood Cream Store, located at 388–390 Washington Street. In 1912, the Hazelwood Cream Store was a confectionery, ice cream parlor, and lunch room managed by J. H. Joyce. By 1931, the Washington Street location was closed and a Hazelwood Confectionery was located at 240 East Broadway Street, with a bakery and stores at several other locations. (Courtesy Dusty Schmidt.)

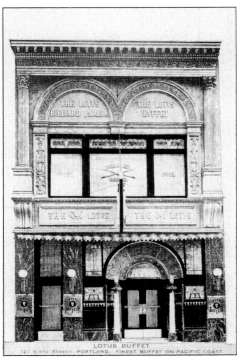

This undated photograph shows the Lotus Billiard Hall and Buffet, located at 127 Sixth Avenue. The Lotus claimed the "Finest Buffet on the West Coast." It was apparently started after 1910. In 1912, Morris Nelson was the proprietor of the Lotus, and in 1914, John E. Kelly was the manager. By the 1930s, this Lotus was gone and a new one was located on Southeast Hawthorne Street. (Courtesy Mark Moore.)

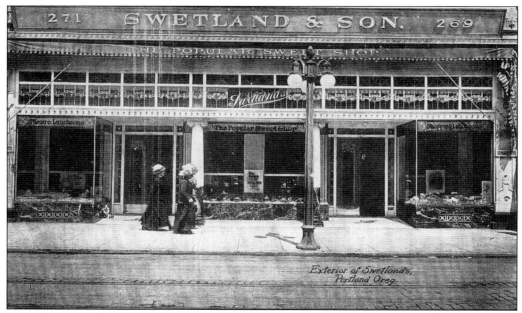

This undated early photograph shows the front of Swetland and Son, a well-advertised candy shop that was located at 292½ Washington Street. The Swetland candy shop was operated by W. K. Rayl in 1927 and Edward Savan in 1928 and apparently went out of business after 1928. (Courtesy Mark Moore.)

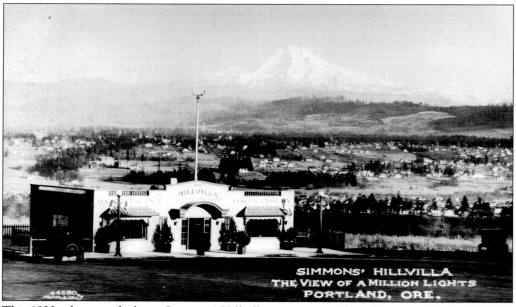

This 1920s photograph shows Simmons' Hillvilla restaurant and confectionery, located at 5700 Southwest Terwilliger Boulevard. The restaurant offered "The View of a Million Lights" and a commanding view of Mount Hood. Operated by Rolla L. Simmons, the Simmons' Hillvilla restaurant and confectionery operated from the 1920s until 1938. (Courtesy Mark Moore.)

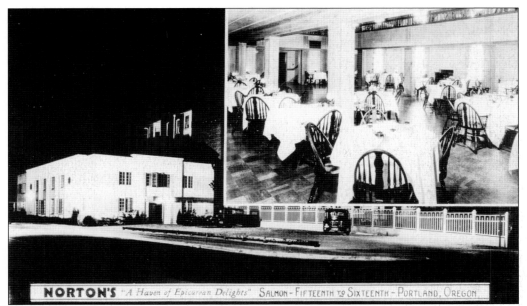

This undated photograph shows Norton's restaurant, "a Haven of Epicurean Delights." Norton's, located on Salmon Street between Fifteenth and Sixteenth Avenues, appears to have been one of Portland's restaurants that catered to elite diners of the day. Norton's restaurant evidently went out of business around 1932. (Courtesy Mark Moore.)

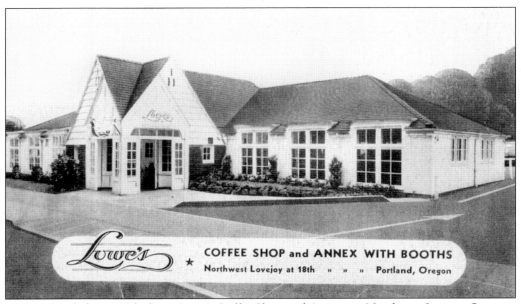

This undated photograph shows Lowe's Coffee Shop and Annex on Northwest Lovejoy Street at Eighteenth Avenue, which was established in 1930 and operated by Mrs. E. E. Bergstrom at least through 1950. The restaurant billed itself as "The House of Quality" and used the slogan "The Man Who Knows, Eats at Lowe's." (Courtesy authors.)

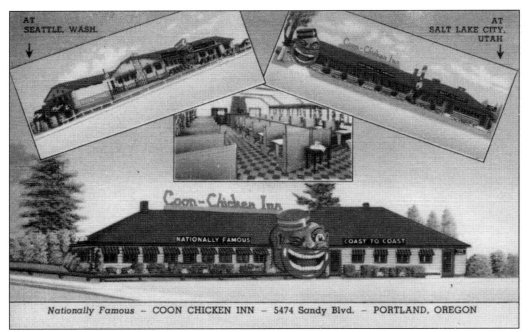

Nationally Famous – COON CHICKEN INN – 5474 Sandy Blvd. – PORTLAND, OREGON

This advertising postcard shows the Coon Chicken Inn, a restaurant chain based in Utah. Opened in 1930 on Sandy Boulevard, the restaurant was known for good food at low prices. The restaurant's trademark logo, a huge stereotype figure surrounding the entryway, became socially unacceptable and the restaurant closed in 1959. The building currently houses Clyde's Prime Rib. (Courtesy authors.)

This undated matchbook cover advertises Bixby's Coffee Shop and Chicken Wing, located on Southwest Stark Street between Eleventh and Twelfth Avenues. Founded by Everett H. Bixby in the 1930s, Bixby's offered banquet rooms, a ladies' lounge, restrooms, and secluded booths. The inside of the matchbook cover advises that "Mrs. Bixby Does the Cooking." (Courtesy authors.)

This undated matchbook cover advertises Bonser's Canary Cottage, located at 1825 Northeast Broadway. Bonser's served lunch and dinner, offering group luncheons and dinners by appointment and boasting of "Home Cooking That Will Please You." The restaurant was known as the Canary Cottage Tea Room from the 1930s into the 1940s and had disappeared by 1950. (Courtesy authors.)

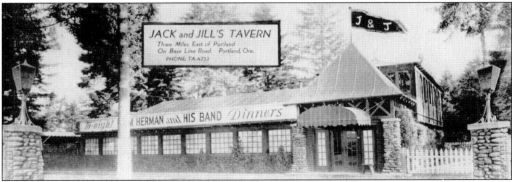

This photograph shows Portland's Jack and Jill's Tavern, located on Stark Street three miles east of downtown Portland. Jack and Jill's offered dancing and chicken and steak dinners and was managed by Earl M. Binford. Legend holds that Binford sold his establishments in downtown Portland and moved his operation to skirt regulations restricting some types of activities at his tavern. (Courtesy Mark Moore.)

This matchbook cover advertises the Broiler restaurant, located on West Park Avenue at Salmon Street. From the 1930s into the 1960s, the Broiler specialized in southern barbecued crab and planked club steak, also offering Pacific seafood, chicken, and prime ribs with "friendly service." In 1940, Wilbur M. Deane was the operator of the Broiler. (Courtesy authors.)

This matchbook cover advertises A Bit of Sweden restaurant, located at 1744 Northeast Forty-second Avenue, near Sandy Boulevard. Operated by A. N. Nelson, F. A. Nelson, and Anna Nelson from the 1930s into the 1950s, A Bit of Sweden was a smorgasbord that offered "Dinners That Are Different" and "Luncheons by Appointment." (Courtesy authors.)

This matchbook cover advertises the Mississippi Tavern, located at 4424 North Mississippi Avenue. Proprietor O. B. Wallace claimed the tavern was "A Clean, Friendly Place to Come." The Mississippi Tavern operated from the 1930s into the 1960s. Various managers of the tavern were Fred L. Paul in 1940, R. C. Gaskill in 1950, and Sam D. Francisco in 1960. (Courtesy authors.)

This undated matchbook cover advertises the Log Cabin Cafe, located at 970 Southwest Broadway. The Log Cabin offered steaks, chicken, seafood, and delicious sandwiches. The Log Cabin claimed, "We Ain't Mad at Nobody." Presumably earlier, in 1937, this same address was occupied by Betty's Barbecue Restaurant. (Courtesy authors.)

This matchbook cover advertises the Hung Far Low Chinese restaurant once located at 112 Northwest Fourth Avenue. From 1928, Hung Far Low specialized in Chinese dishes and was open from lunch into the early-morning hours. Wong On was the owner of Hung Far Low. In 2005, the restaurant closed after 77 years in Chinatown and later reopened at the corner of Southeast Eighty-second Avenue and Division Street. (Courtesy authors.)

This matchbook cover advertises Hilaire's Restaurant, located on Southwest Washington Street "sixty steps below Broadway." From the 1930s into at least the 1980s, Hilaire's offered sizzling steaks, unusual food, a soda fountain, dinners that "you'll remember," and "distinctive homemade ice cream." Owner Larry Hilaire claimed, "The Best People in the World are my Customers." (Courtesy authors.)

Likely a well-known participant in Portland's 1940s nightclub scene was Hazel Stone Rex, advertised on this matchbook cover. An all-around licensed and bonded theatrical entertainer operating from 20 Northwest Sixteenth Avenue, "Rexy" offered music and entertainment for all occasions and floor shows from the 1930s into the 1940s. (Courtesy authors.)

This World War II–era scene shows the Jug restaurant and beer parlor located in north Portland at the intersection of North Portland Road and North Denver Avenue. In the foreground is a Mobilgas gasoline station. The Jug, a classic example of "mimetic" architecture, operated during the 1930s and 1940s. (Courtesy Oregon State Archives.)

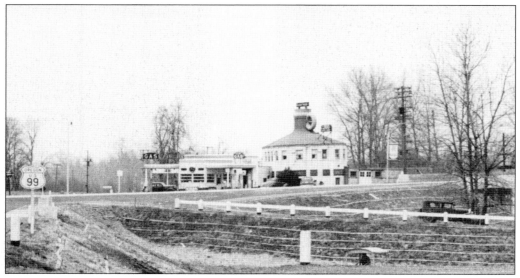

This matchbook cover advertises the Oyster Loaf, located at 312 Southwest Broadway Street. Proprietors Rohde and Rupert kept the restaurant open from 7:00 a.m. to 1:00 a.m. serving barbecued crab, baked crab loaf, seafood cocktails, Olympia oysters, steaks and chops, Crab Louis, Olympia pan roasts, Olympia oyster loaf, and breakfast. (Courtesy authors.)

This matchbook cover advertises Casey's Tavern, located at 7901 Southeast Foster Road. Casey's offered French fried hamburgers. In 1943, Casey's was operated by Casey Hutchinson. Casey apparently sold the tavern, and during the 1950s, this address was the home first to Cliff's Tavern, then Esther and Steve's Tavern, later Mary's Tavern, and currently Andy's Inn. (Courtesy authors.)

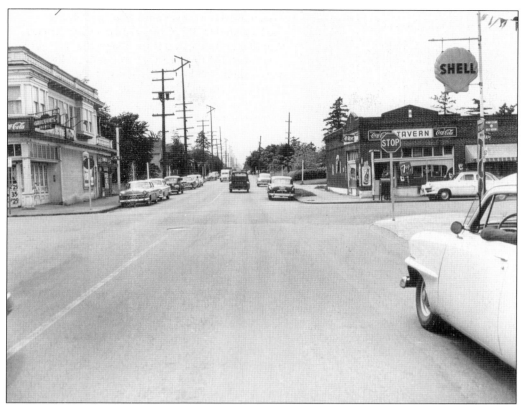

This 1954 photograph shows the Ark Tavern at the intersection of Northeast Killingsworth Street and Thirtieth Avenue. The Ark Tavern was in operation from the 1930s into the 1980s, managed by John S. Ketrenos and Robert J. Ketrenos in 1931 and Delores L. Rider in 1985. Nearby is a Shell gasoline station, and a 1952 Ford is parked at left. (Courtesy City of Portland Archives.)

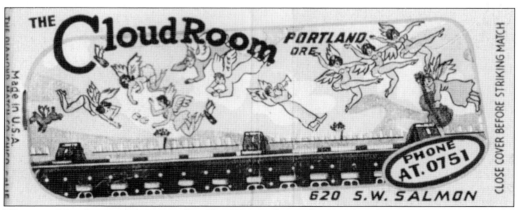

This matchbook cover advertises the Cloud Room, located at 620 Southwest Salmon Street. The Cloud Room was one of a number of nightclubs—including the Pago Pago Club, the Clover Club, the King of Clubs, the Star, and the Chicken Coop—that operated during the shipbuilding boom of World War II. (Courtesy authors.)

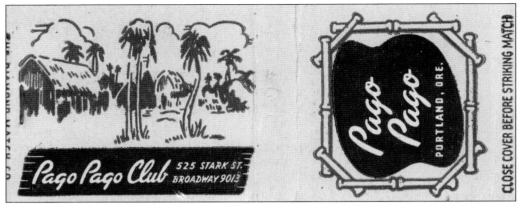

This matchbook cover advertises the Pago Pago Club, located at 525 Southwest Stark Street and 9013 Broadway Street. The Pago Pago Club was a Polynesian-theme club featuring "America's Most Beautiful Tropical Room" and serving Chinese, "American and Tropical Cuisine." Upstairs was the Turf Club, an illegal gambling operation. Owned by reputed gambling boss attorney Al Winter, Pago Pago evidently operated from the 1940s until closing in 1951. (Courtesy authors.)

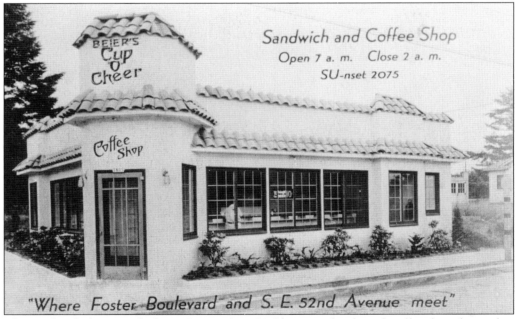

This undated photograph shows Beier's Cup O' Cheer sandwich and coffee shop, located at the corner of Foster Road and Fifty-second Avenue. A sign in the window of the coffee shop advertises draught beer for 10¢. Beier's hours of operation were 7:00 a.m. to 2:00 a.m. (Courtesy Mark Moore.)

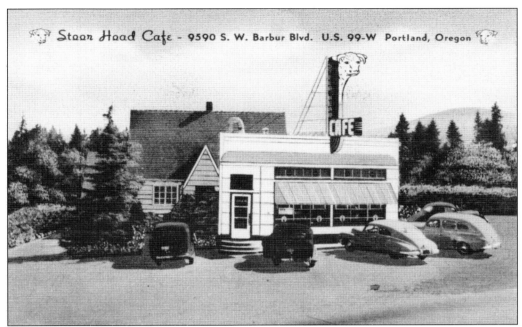

This scene shows the Steer Head Café, located at 9590 Southwest Barbur Boulevard, also known as U.S. Route 99W. The Steer Head claimed to be "A Nice, modern, café specializing in chicken and steak dinners. Table and Counter Service." The Steer Head was open from 6:00 a.m. until 2:00 a.m. seven days a week. (Courtesy authors.)

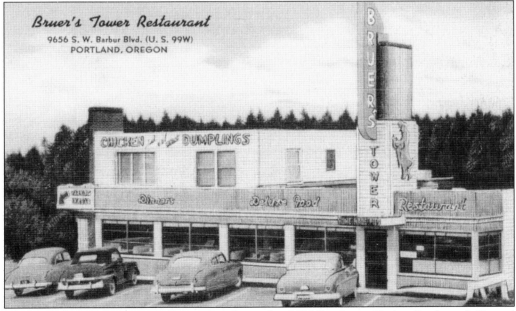

This view shows Bruer's Tower Restaurant, located at 9656 Southwest Barbur Boulevard. Owned and managed by George and Rosalie Bruer in the early 1950s, the restaurant specialized in chicken and dumplings and was open seven days a week. In 1955, the Bruers became owners of Bruer's Whistlin' Pig on Southwest Broadway. (Courtesy Mark Moore.)

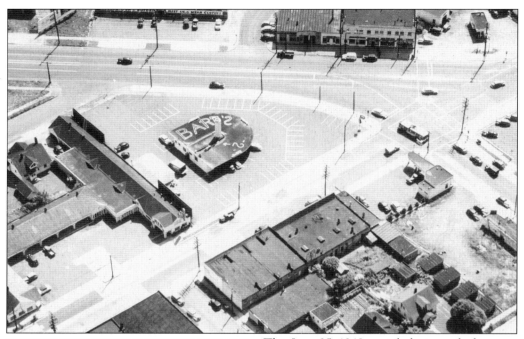

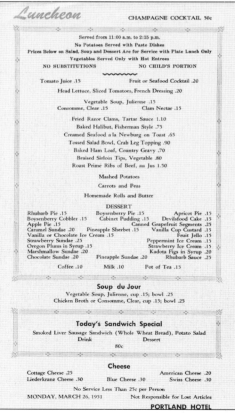

This June 25, 1948, aerial photograph shows Bart's drive-in, located at the intersection of Southeast Foster Road and Fiftieth Avenue at Powell Boulevard. The significance of the backward "S" is unclear. A number of other restaurants have occupied this site, including a Kentucky Fried Chicken and the Speck restaurant. The building was torn down, and currently a Burger King occupies this location. (Courtesy City of Portland Archives.)

This menu from the Portland Hotel dates from its last days before demolition in 1951. The Portland's dining room contained 11 sets of Haviland china, each purchased for a visiting president. The seven-story Queen Anne chateau-style Portland Hotel featured dormered steep roofs, a porte cochere courtyard with blue hydrangeas, wrought-iron entry gates and railings, and carriage lamps. (Courtesy Mark Moore.)

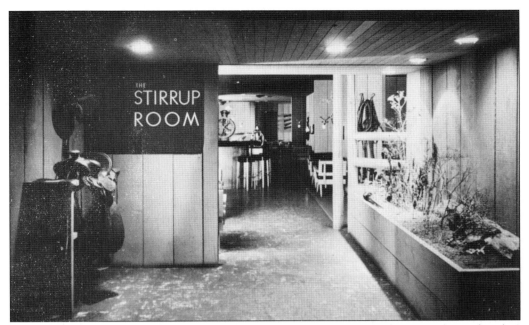

This undated photograph shows the Stirrup Room, a Western-theme restaurant located within the Hotel Multnomah. The Stirrup Room specialized in its "chuckwagon lunch" and "distinctive hors d'oeuvres." The Stirrup Room was twice named by *Holiday Magazine* as one of the "75 outstanding restaurants in the United States." (Courtesy authors.)

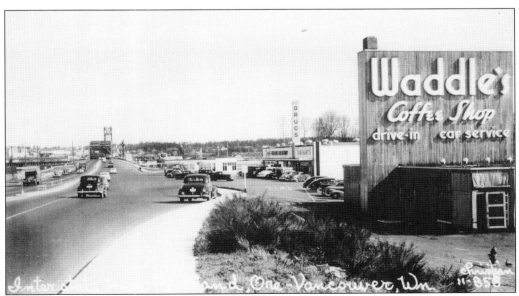

This undated photograph shows Waddle's Coffee Shop with the Interstate Bridge visible in the background. Founded by Gene and Natha Waddle in 1938 and opened at this site on September 1, 1945, Waddle's closed in May 2004 to make way for a planned Krispy Kreme shop and was actually replaced with a Hooters restaurant. (Courtesy Stephen Kenney Jr.)

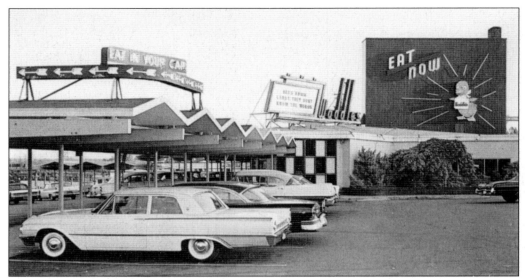

This early-1960s photograph shows a 1961 Ford at left and other automobiles parked at Waddle's Coffee Shop, located at 11900 North Highway 99, just south of the Interstate Bridge. In addition to Waddle's trademark "Eat Now" sign, Waddle's also used the slogan "Walk In, and Waddle Out." The building was designed by Portland's internationally renowned architect Pietro Belluschi. (Courtesy authors.)

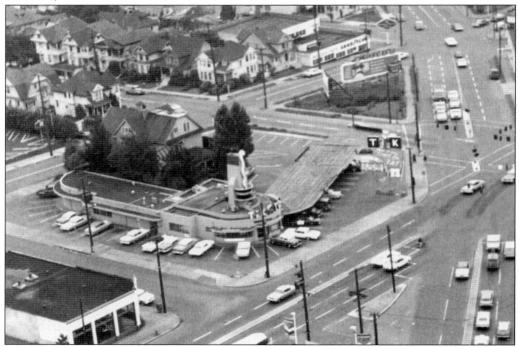

This photograph shows the Tik Tok sandwich shop. The Tik Tok's slogan was "Time to Eat," which complimented the clock that fit between the "Tik" and "Tok" in the sign on the building. A separate sign at the intersection featured the stationary letters "T" and "K" on either side of a rotating panel with "i" on one side and "o" on the other. (Courtesy City of Portland Archives.)

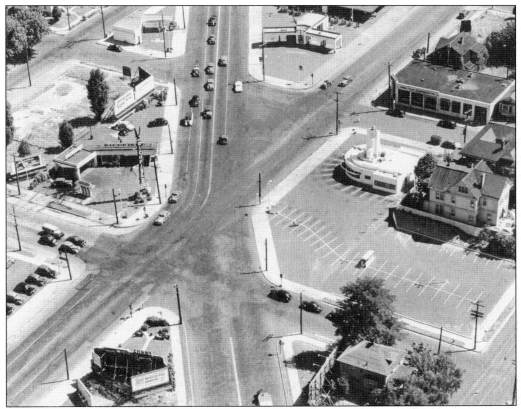

This photograph shows the Tik Tok restaurant at the intersection of Northeast Sandy Boulevard, Burnside Street, and Twelfth Avenue. The Tik Tok, which was owned by Horace Williams, was a popular drive-in restaurant and featured sandwiches, hamburgers, barbecued meats, a soda fountain, and car service. (Courtesy City of Portland Archives.)

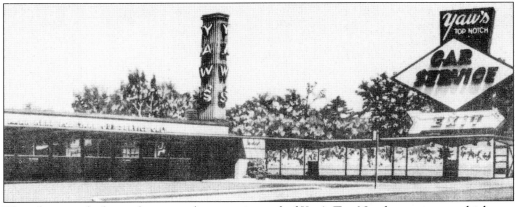

This photograph shows the covered car service end of Yaw's Top Notch restaurant, which was founded by W. P. and Grace Yaw in 1926 and moved into the building shown at 2001 Northeast Fortieth Avenue in 1955. W. P. Yaw collaborated with E. E. Franz of Portland's Franz Bakery to invent the five-inch hamburger bun in the late 1920s and is also credited for the thick milk shake. (Courtesy Mark Moore.)

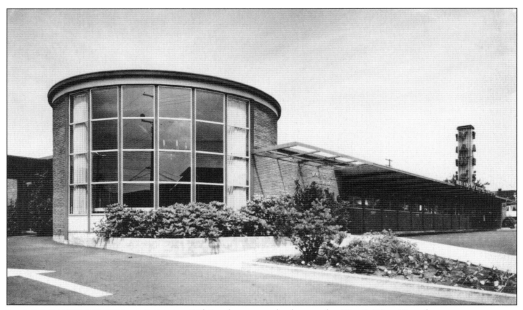

This photograph shows the Yaw's Top Notch restaurant, which developed a reputation for the best hamburgers in Portland. Located in the Hollywood district near Grant High School, Yaw's became a favorite spot for youth and a popular cruising stop. At the peak of its operation, Yaw's employed 180 workers. Yaw's closed in 1982. (Courtesy Mark Moore.)

This matchbook cover advertises the Henry Thiele restaurant, located at 2305 West Burnside Street, using a photograph of the proprietor. In addition to his restaurant, Thiele also ran a catering operation that traveled on motorcycles with sidecars, delivering box lunches during the early years of his restaurant. In addition, Thiele was the head chef at the Pacific International Livestock Exposition. (Courtesy authors.)

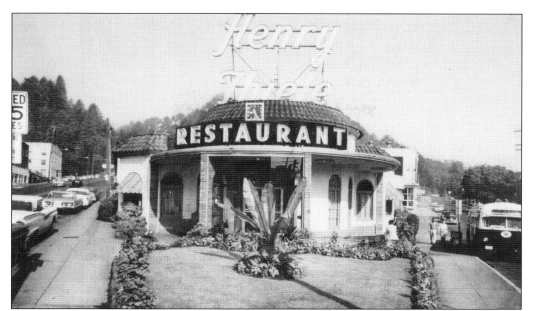

This photograph shows Portland's well-known Henry Thiele restaurant. Henry Thiele started the restaurant in 1932 that became a popular dining spot specializing in German foods. After Henry's death in 1952, his widow, Margaret, operated the restaurant with her second husband, August Petti, until selling the restaurant in 1990. Thiele Square was built on the site in 1995. (Courtesy Mark Moore.)

This matchbook cover advertises the George Lewis Café, located at the new Union Bus Terminal at the corner of Southwest Fifth Avenue and Taylor Street. George H. and Lena Lewis opened the café during the 1940s. By 1960, Nicholas D. and Violet E. Daimond operated the café and a newsstand. (Courtesy authors.)

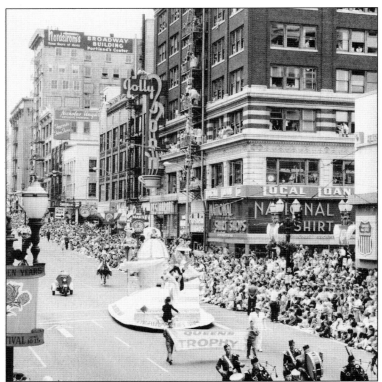

This scene from the 1958 Portland Rose Festival shows the popular Jolly Joan sandwich shop, "where you eat best for less." The Jolly Joan was apparently in business at least from the 1930s into the 1960s. Reputed to be the largest restaurant in the state of Oregon, Jolly Joan included the Lariat Lounge. (Courtesy Oregon State Archives.)

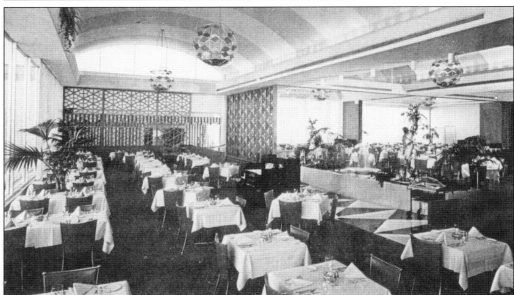

This view shows the interior of the Aladdin Restaurant on the third story of the Meier and Frank department store at the Lloyd Center shopping mall. The Aladdin, which opened in 1960, offered Meier and Frank shoppers fine dining with a view of the mall's ice rink. The Aladdin closed in 1990 for a major renovation of the mall and was replaced with a mall food court. (Courtesy Mark Moore.)

This undated photograph shows Davey's Locker, located within the Jackson Tower on Broadway Street from the 1950s into the 1970s. Davey's offered "the finest in charbroiled steaks, seafood and delicious salads" in a marine setting. The Jackson Tower was built in 1912 and housed the *Oregon Journal* newspaper until 1948, when the *Journal* moved to the old Public Market Building. (Courtesy authors.)

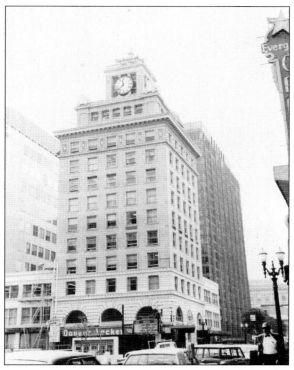

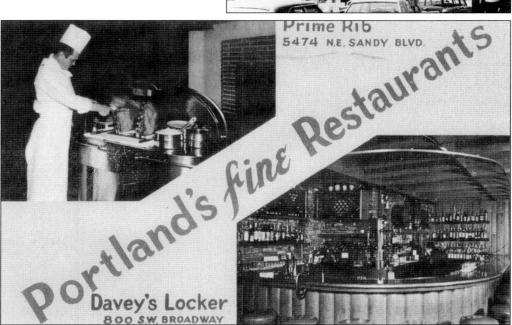

This undated advertising postcard shows scenes from both Davey's Locker at 800 Southwest Broadway and the Prime Rib located at 5474 Northeast Sandy Boulevard. The back of the card advises, "Eddie Mays welcomes you to two of Portland's fine restaurants. The Prime Rib for the best in prime ribs and steaks and Davey's Locker for delicious seafood and charcoal broiled steaks." (Courtesy City of Portland Archives.)

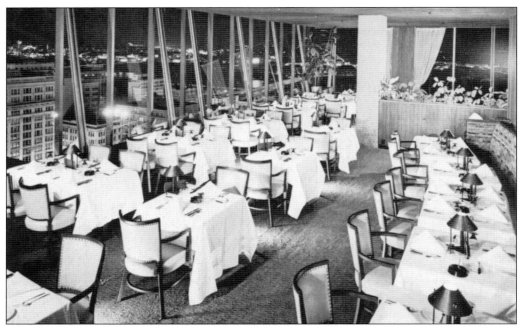

This undated photograph shows the interior of the Canlis' Charcoal Broiler atop the Portland Hilton Hotel. Offering "Epicurean dining at one of the world's most beautiful restaurants and lounges . . . with a sweeping view of the city from Oregon's tallest building," Canlis' also claimed locations in Seattle, Washington, and Honolulu, Hawaii. Operating from the 1950s into the 1980s, Canlis' was managed by John Welton in 1980. (Courtesy authors.)

This undated photograph from the early 1960s shows Rose's 24 Flavors Ice Cream Store. Henry Hansen was the owner of Rose's, which sold only ice cream, hamburgers, and "broasted" chicken. All orders were on a to-go basis as there was no seating available inside the store. (Courtesy Nelson family archives.)

This March 22, 1965, photograph shows the Bohemian, located at 910 Southwest Washington Street. The Bohemian offered "irresistible pastries [that] complete a delicious and varied menu at moderate prices." The Bohemian, run by Isaac Neuberger, was in operation from the 1930s into the 1970s and at one time included a sandwich shop at 127 West Park Avenue. (Courtesy City of Portland Archives.)

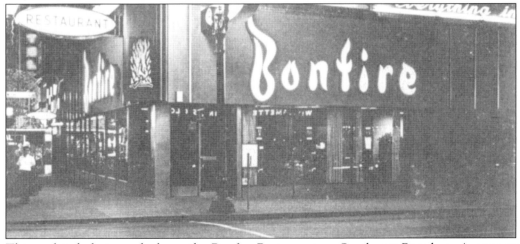

This undated photograph shows the Bonfire Restaurant on Southwest Broadway Avenue at Washington Street. The Bonfire claimed to be Portland's finest dining spot and also served beverages in its intimate "My Office" lounge. The restaurant encouraged parents to bring children, offering a special "kiddies menu." The Bonfire operated at this site from the 1960s into the 1980s. A Bonfire lounge is currently located at 2821 Southwest Stark Street. (Courtesy authors.)

This undated photograph shows the Chinese Gardens exotic Chinese restaurant, which was located at 625 Northeast 122nd Avenue, across 122nd from Menlo Park Plaza and near Northeast Glisan Street. The Chinese Gardens offered gourmet Chinese dinners, American dishes, banquet rooms, and take-out orders. Today in Portland, Chinese Garden refers to a one-city-block traditional Chinese garden between Northwest Second and Third Avenues and Northwest Flanders and Glisan Streets. (Courtesy Mark Moore.)

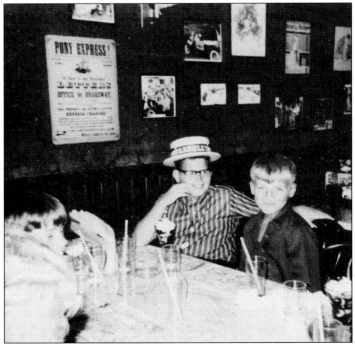

This October 9, 1971, photograph shows the interior of a Farrell's ice cream parlor. The occasion is the birthday of Craig Norman, wearing the special Farrell's birthday hat and sitting with friend Mike Freier. Founded by Bob Farrell in Portland in 1963, Farrell's featured a "1905" theme and specialized in birthdays. The Portland Farrell's was sold in the mid-1990s and became the Original Portland Ice Cream Parlour. (Courtesy Esther Norman.)

Three

BUILDINGS AND STREETSCAPES

One of the most visible things in a city is the buildings. Their architecture is an expression of their designers, their original owners, and the times in which they were built.

Portland has a mixture of brick, cast-iron, reinforced concrete, and steel-frame buildings of widely varying ages. While renovation and reuse of historic buildings is becoming popular today, many early buildings have already been razed to make room for more modern buildings and structures like parking garages. An example of this is the demolition of the Portland Hotel in 1951 for Meier and Frank's parking garage. During the 1980s, the parking garage was removed and the site became Pioneer Courthouse Square, named after the courthouse across the street. This chapter shows some of the buildings that have vanished to make room for more modern structures.

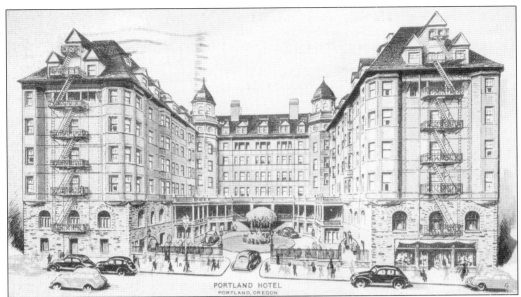

This postcard view shows the Portland Hotel, designed by architects McKim, Mead, and White and built in about 1890. The Portland Hotel had six floors and a total of 284 rooms, a dining room seating 224, and a breakfast room seating 124. Demolished in 1951 for construction of Meier and Frank's parking garage, the site became Pioneer Courthouse Square during the 1980s. (Courtesy City of Portland Archives.)

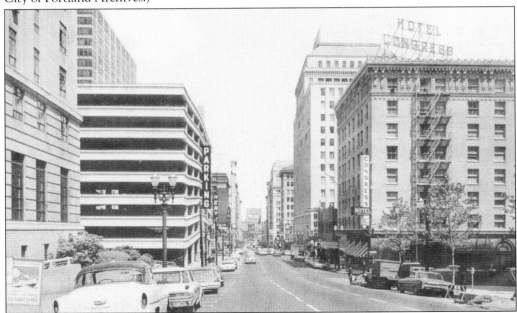

This 1960s photograph shows Sixth Avenue, with the Hotel Congress and Pacific Power at the right. The Hotel Congress was designed by Herman Brookman, built in 1912, and demolished in 1977. The large sign atop the Pacific Power building was removed in 1972. In the distance is a large "welcome" sign in an outline of Oregon, and at the left is a Coast Guard recruiting poster. (Courtesy authors.)

This matchbook cover advertises the St. Francis Hotel, located at the corner of Southwest Eleventh Avenue and Main Street. The white brick St. Francis was featured in the Gus Van Sant film *Drugstore Cowboy*. A very tired St. Francis was demolished in 2001 to make way for the St. Francis Apartments. It is part of the Museum Place—three blocks of mixed housing and retail development. (Courtesy authors.)

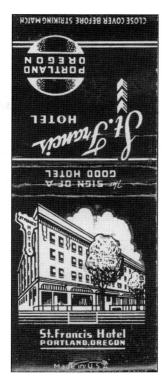

This undated photograph shows the house built for Julius Loewenberg in 1892, located on Southwest Park Place near the entrance to Washington Park. Later owned by F. W. Leadbetter, the house was donated to the Oregon Historical Society in 1951, used as a museum until 1954, and torn down in 1960. The site is currently occupied by apartments. (Courtesy Nelson family archives.)

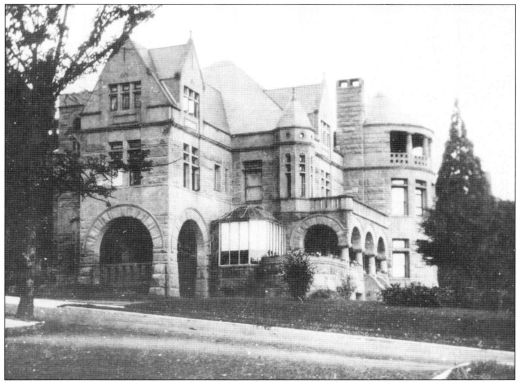

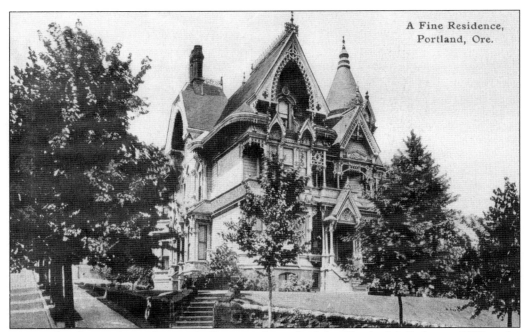

This undated view shows the stately Victorian home built by Charles M. Forbes in 1892 at the corner of Vista Avenue (formerly Ford Street) and Park Place. Later residents included Henry W. Goode, general manager of Portland General Electric, and Graham Glass of the Glass and Prudhomme Printing Company before the house was torn down in 1930. Currently the site houses the 1958 Park Vista apartment building. (Courtesy Nelson family archives.)

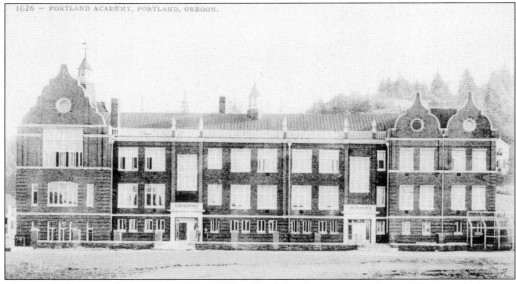

This early photograph shows the home of Portland Academy on Southwest Thirteenth Avenue at Montgomery Street. The school was founded in 1859, expanding into this building designed by Whidden and Lewis and built between 1889 and 1895, moving to Raleigh Hills in 1936 as Miss Gabel's School, and merging with Miss Catlin's School in 1957 to form Catlin Gabel School. Freeway construction removed the building in 1965. (Courtesy authors.)

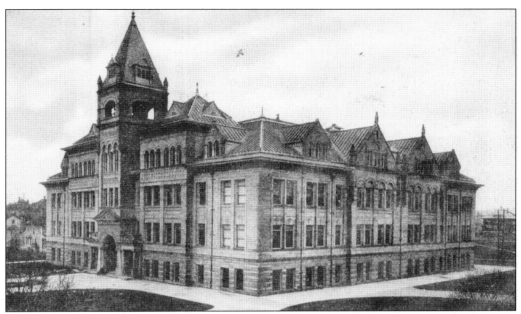

This photograph shows Washington High School as it appeared in 1910. Known as the East Side High School when built in 1889, it changed its name to Washington High School in 1909. The school was closed in the 1980s, and some of its programs shifted to Benson High School. (Courtesy City of Portland Archives.)

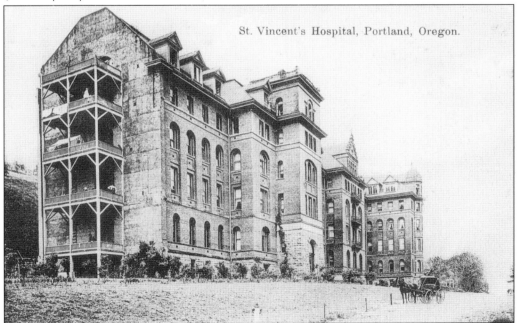

St. Vincent's Hospital, Portland, Oregon.

This 1909 photograph shows Portland's second St. Vincent's hospital, operated by the Sisters of Providence. This facility, which included an elevator to move patients, was built in 1895 and operated until the current St. Vincent's hospital was opened in 1971. The building was demolished in the late 1970s. (Courtesy City of Portland Archives.)

This early scene shows the *Oregonian* Building, built in 1892 at the corner of Southwest Sixth Avenue and Alder Street. The building was nine stories tall, not including the tower, which added three stories. The *Oregonian* newspaper occupied the building until its new headquarters were built in 1948, and the building was torn down in 1950. (Courtesy Multnomah County Library.)

This 1925 photograph shows the Portland West Side Auto Camp, located on Sixth Avenue south of Terwilliger Boulevard. The Auto Camp boasted 43 cottages, with "Every Modern Convenience" and a "Beautiful Grove for Campers." Showers, laundry, gas, and water were available, along with a real estate office. The camp operated approximately from the 1930s into the 1950s. (Courtesy City of Portland Archives.)

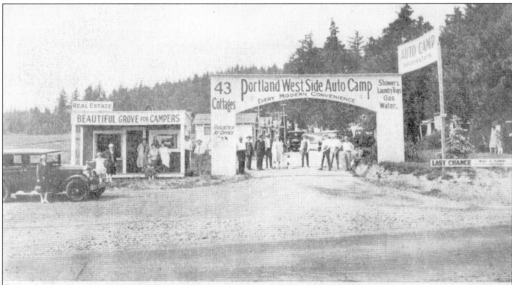

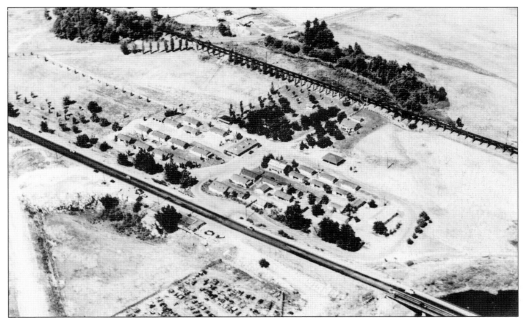

This undated aerial photograph shows the Portland Auto Camp, located at 9000 North Union Avenue. The Portland Auto Camp claimed to be the "Best in Portland, 75 modern cottages and camping space on Pacific Highway north end of Union Avenue." The Portland Auto Camp apparently closed during the 1940s. (Courtesy Mark Moore.)

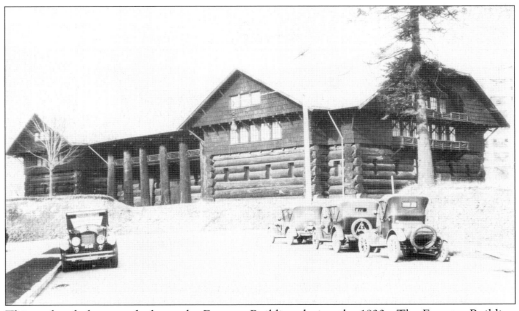

This undated photograph shows the Forestry Building during the 1920s. The Forestry Building was built for the Lewis and Clark Centennial Exposition held in northwest Portland in 1905. The Forestry Building, also known as the "World's Largest Log Cabin," was 206 feet long, 102 feet wide, and 72 feet high, built from massive logs. (Courtesy City of Portland Archives.)

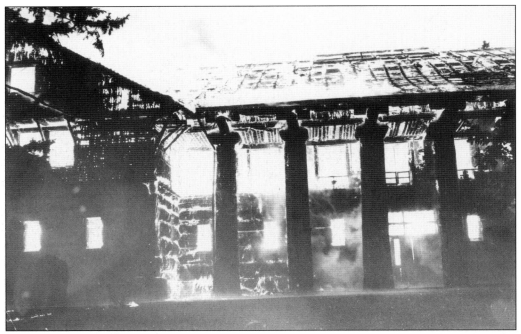

This August 17, 1964, photograph shows Portland's Forestry Building, one of the few if not the only building preserved from the 1905 Lewis and Clark Exposition, burning. The building was a total loss. Located at 2771 Northwest Upshur Street, the Forestry Building featured massive columns made from old-growth logs. (Courtesy City of Portland Archives.)

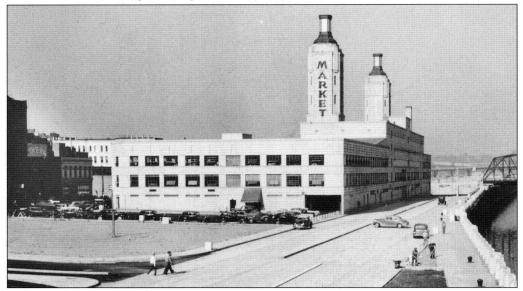

This undated photograph shows the Portland Public Market building that the federal government constructed in 1933 as a place to consolidate Portland's farmer's market, which had been outdoors on Southwest Yamhill Street. The two-and-a-half-block-long reinforced-concrete building became a U.S. Navy storage facility during World War II and later housed the *Oregon Journal* newspaper. It was torn down by 1970. (Courtesy Oregon State Archives.)

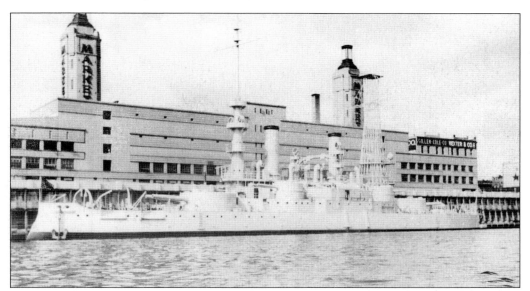

This view shows the battleship USS *Oregon* in the Portland Harbor near the Public Market building. The *Oregon* helped to destroy the Spanish fleet in the Spanish-American War. In 1925, the *Oregon* was berthed near the Broadway Bridge, and in 1938, it was towed to the Battleship Oregon Memorial Park, near the Hawthorne Bridge. (Courtesy Mark Moore.)

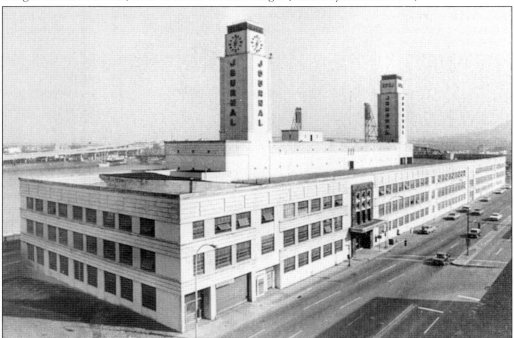

This 1969 photograph shows the *Oregon Journal* building, formerly known as the Public Market building, looking from the west. The *Journal* started in 1902 and occupied the first *Oregon Journal* building, later renamed the Jackson Tower, on Broadway from 1912 until 1948. In 1948, the *Journal* moved into the former Public Market building, remaining there until being merged with the *Oregonian* in 1961. (Courtesy City of Portland Archives.)

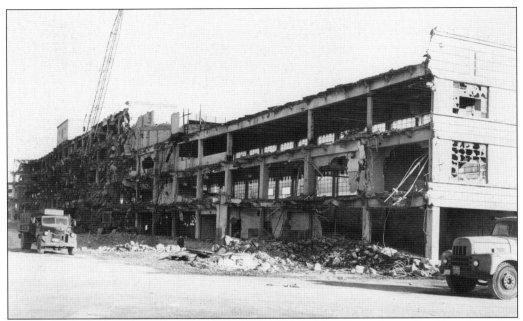

This January 7, 1970, photograph shows the demolition of the *Oregon Journal* building. The City of Portland acquired the building and demolished it to make room for a planned expansion of Harbor Drive. Public sentiment favored access to the Willamette River waterfront, and Harbor Drive was removed in 1974 to create Waterfront Park. (Courtesy City of Portland Archives.)

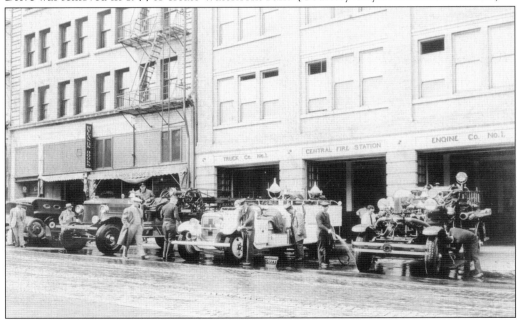

This 1929 photograph shows fire crews and firefighting apparatus outside of Portland Fire and Rescue's Central Station at 905 Southwest Fourth Avenue, also known as Station No. 1. Truck No. 1 is a 1928 Ahrens-Fox, Squad No. 1 is a 1928 Studebaker, and Engine Company No. 1 is a 1928 Ahrens-Fox. (Courtesy City of Portland Archives.)

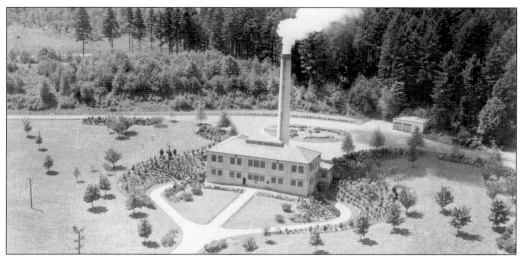

This May 13, 1940, photograph shows the city incinerator, which opened in 1932 on Swift Boulevard, part of today's Columbia Boulevard, and was used until 1970. It was used in conjunction with the St. Johns Landfill located across the street. The facility was converted into the City of Portland's Archives and Records Center in 1981, and the chimney was removed in 1990. (Courtesy City of Portland Archives.)

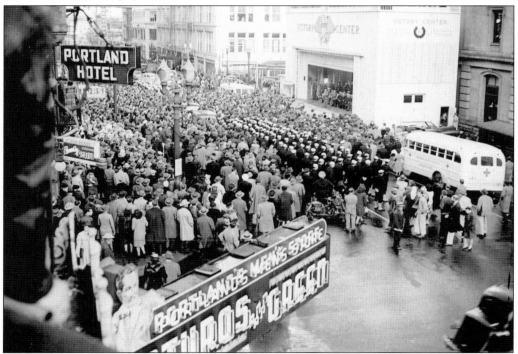

This 1945 scene shows something never seen in Portland since, a celebration at the end of World War II. Admiral Halsey held the event at the Victory Center, an evidently temporary structure built on the sidewalk across the street from the Portland Hotel. The banner on the side of the Victory Center proclaims "Far They Ventured in the Cause of Freedom." (Courtesy City of Portland Archives.)

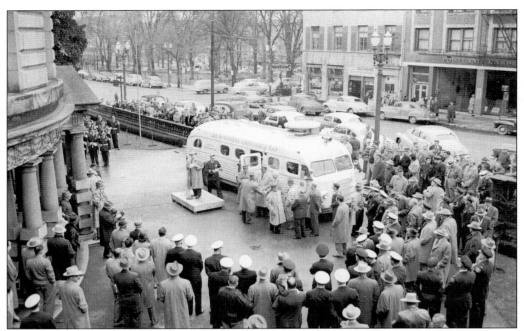

This 1953 scene shows the rededication of the Portland Fire Department's upgraded "J. W. Stevens Emergency Car," equipped for disasters and often used in school visits. The 1939 Stevens Car was funded by businessman Aaron Frank and built by Wentworth and Irwin on a Kenworth chassis. Frank also funded its upgrade for the needs of 1950s civil defense. (Courtesy City of Portland Archives.)

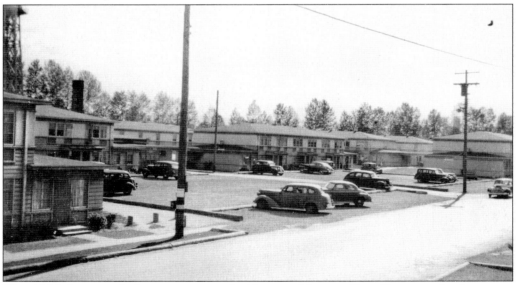

This 1946 photograph shows apartment buildings in Vanport City. Vanport, also known as "Kaiserville," was built by Henry J. Kaiser's organization during 1943 to house wartime shipyard workers and contained 700 apartment buildings, 17 multiple-dwelling units, and 9,942 individual housing units. By November 1943, Vanport was home to nearly 40,000 people, almost 15,000 of whom were African American. (Courtesy Nelson family archives.)

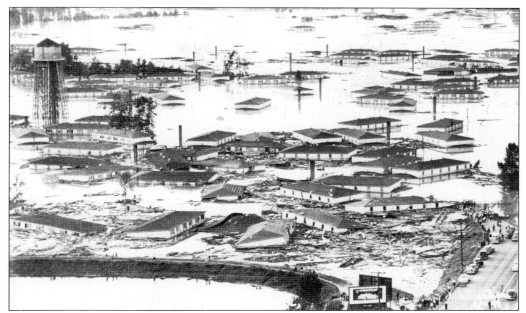

Seen here is the Vanport flood while citizens look on from the remaining portion of the dike. Waters were approximately 15 feet deep in the area and even reached the highest part of the project on Denver Avenue. Thousands, including the Multnomah County sheriff's deputies, were inoculated against typhoid. (Courtesy authors.)

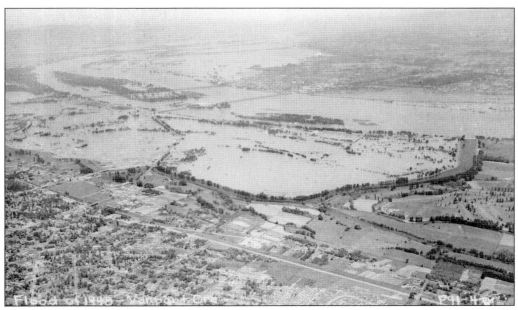

This aerial photograph shows the Vanport flood looking over the floodplain area between the Columbia Slough and the Columbia River, with the Union Pacific Railroad Bridge and the Interstate Bridge visible. The dike failed at about 4:17 p.m. on May 30, 1948, allowing a 10-foot-high wall of water to sweep through the area before it became inundated approximately 35 to 40 minutes later. (Courtesy authors.)

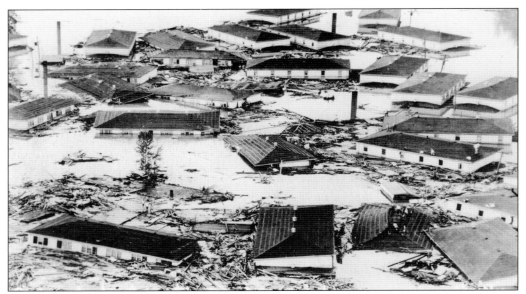

This photograph shows some of the houses in Vanport City where the flood deposited them. Suddenly homeless, flood victims had difficulty finding and paying for temporary accommodation. Many protested housing profiteering, unemployment, and lack of support from public housing agencies in front of city hall on June 20, 1948. (Courtesy authors.)

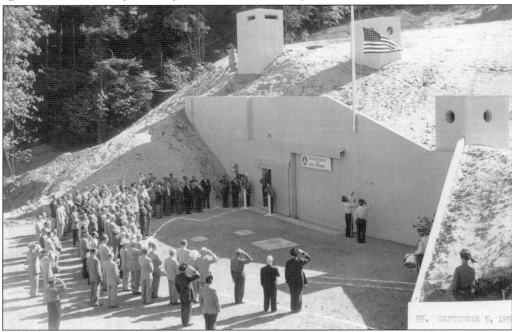

This 1956 photograph shows the dedication of the Kelly Butte fallout shelter, near the intersection of Southeast Division Street and Twelfth Avenue. The shelter was designed to survive a "near miss" of a 20-megaton bomb and to sustain some of the city's executive and emergency personnel for up to 90 days. It was used as an emergency dispatch center later and today is vacant. (Courtesy City of Portland Archives.)

This 1957 photograph shows schoolchildren participating in a cold war–era drill. Portland took civil defense seriously, staging a massive drill called Operation Green Light in 1955 in which the entire downtown section was evacuated. A CBS television documentary titled *The Day Called 'X'*, narrated by Glenn Ford, showed the evacuation and simulated emergency operations within the Kelly Butte fallout shelter. (Courtesy City of Portland Archives.)

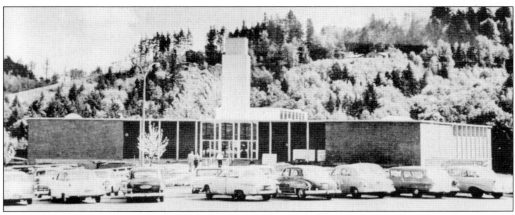

The original Oregon Museum of Science and Industry (OMSI) was adjacent to the Washington Park Zoo. Built in 1955 entirely with volunteer contributions, the $2-million museum provided great educational opportunities for countless children and adults. A planetarium was added, and over the years, the facility outgrew this location. In 1992, OMSI moved to 1945 Southeast Water Avenue along the Willamette River. (Courtesy authors.)

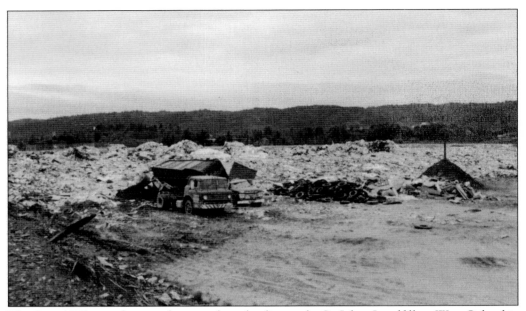

This June 1974 view shows garbage trucks unloading at the St. Johns Landfill on West Columbia Boulevard. The St. Johns Landfill began taking refuse in 1940, was expanded during the 1980s, and closed in 1991 when Portland's refuse could be taken to the new Columbia Ridge Landfill in Arlington, Oregon. (Courtesy City of Portland Archives.)

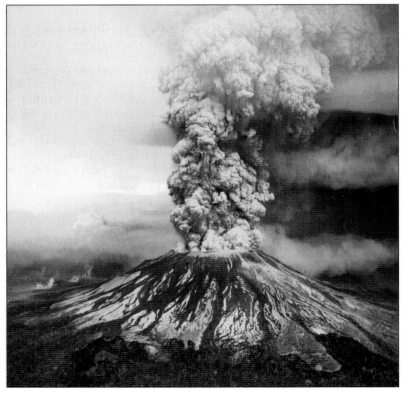

This May 18, 1980, photograph by Robert Krimmel shows the eruption of Mount St. Helens northeast of Portland in Washington state. This deadly eruption killed 57 people, deposited a layer of volcanic ash in the Portland area, and changed the view from Portland dramatically. St. Helens lost its top 1,314 feet, reducing its height to 8,363 feet and destroying its very symmetric appearance. (Courtesy U.S. Geological Survey.)

Four

TRANSPORTATION

Transportation has played a major role in Portland's development as Oregon's largest city. In its early years, Portland grew because of its strategic location as a port for oceangoing vessels and the availability of wheat, wool, timber, and other commodities to ship.

While the Willamette River made navigation possible, it also formed a significant barrier to land transportation. Beginning in 1886, Portland has had bridges across the river. The earliest bridges were swing-type drawbridges, but as automobile traffic increased, the slower opening and closing swing-type drawbridges began to be replaced by faster types of drawbridges. In 1917, a bridge was completed across the Columbia River to Vancouver, Washington.

During the late 19th century and the first half of the 20th century, streetcars were used to help people get around Portland; however, by 1958, the streetcars were replaced by buses.

During the late 1920s and 1930s, Portland's airport was located at Swan Island. By 1940, the Swan Island location was too small and a new airport was opened along the Columbia River, where it remains today.

In the 1960s, freeways were completed to help move automobile traffic through and around Portland.

Today transportation is as important to Portland as ever, and shipping remains important in Portland, with the Port of Portland operating terminals on the Willamette River and the Columbia River.

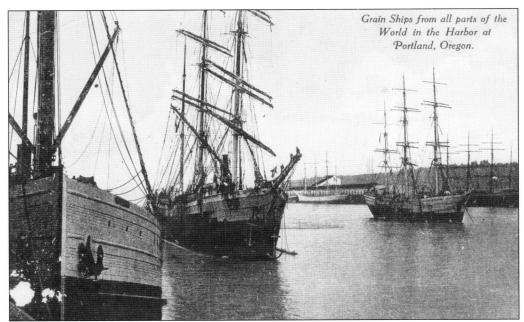

This 1910 scene shows sailing ships in Portland's congested harbor waiting to be loaded with wheat for export. While Portland is still an important wheat port, and today's grain ships represent countries as diverse as in this 1910 scene, the handling of wheat and the ships themselves are nothing like in this scene. (Courtesy City of Portland Archives.)

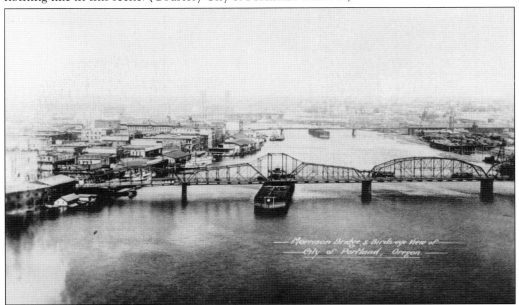

The Morrison Bridge, a swing-type drawbridge, was built in 1905. The Morrison Bridge was damaged by flooding in 1948 and was kept out of service to automobile traffic for a month. This one-month closure and the slower operating characteristics of a swing-type drawbridge prompted its replacement with a faster-operating bascule-type drawbridge during 1956 through 1958. (Courtesy City of Portland Archives.)

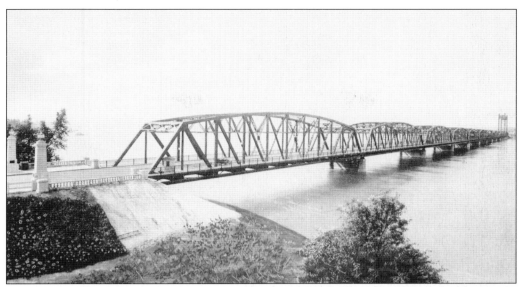

This photograph shows the Interstate Bridge before extensive modifications and addition of a twin structure in 1960. Originally the bridge carried a low-level roadway, but the bridge was raised and two of the original trusses were replaced with one longer truss to provide an alternate channel, allowing some river traffic to pass without a bridge lift. These modifications created today's "hump" in the roadway. (Courtesy Multnomah County Library.)

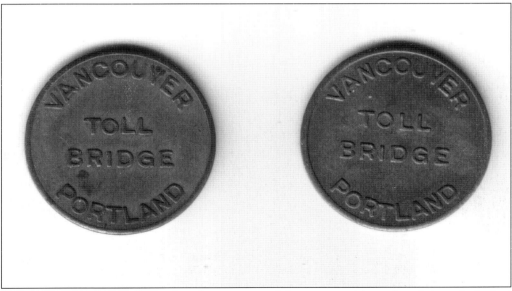

Beginning January 12, 1960, after the opening of the new southbound and the refurbished northbound Columbia River Interstate Bridges, commuters faced a 20¢ toll per crossing. They could buy 40 of these tokens for $6 and save 5¢ each time they crossed. The bridge debt was paid off and the toll was lifted on November 1, 1966, and Portland's bridges have been free of tolls ever since. (Courtesy authors.)

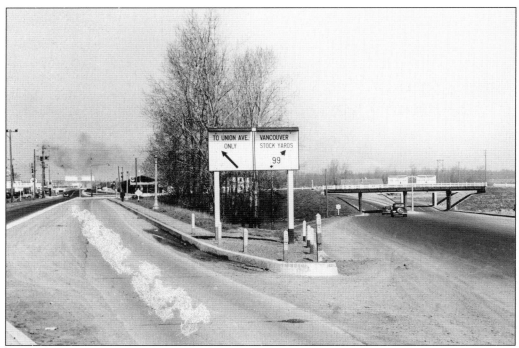

Pictured here are road signs for Union Avenue and for the stockyards. A Portland City Council ordinance renamed Union Avenue as Martin Luther King Jr. Boulevard, in honor of the slain civil rights leader, on April 20, 1989. Interstate 5 replaced U.S. 99 as the main route through north Portland in 1964, and the Portland Union Stockyards closed in 1988. (Courtesy Oregon State Archives.)

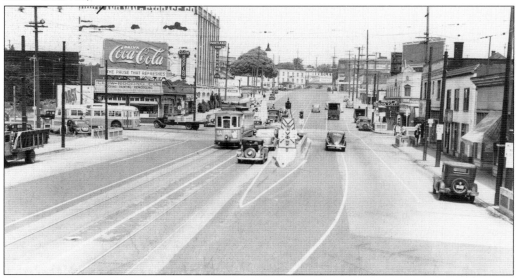

This 1939 photograph shows North Broadway Street at Interstate Avenue looking east. Visible are a streetcar, a city bus, and the unique subway in the center of the street used by passengers boarding the streetcars. Regular city streetcar service ended early in 1950, while some interurban streetcar lines continued until 1958. (Courtesy City of Portland Archives.)

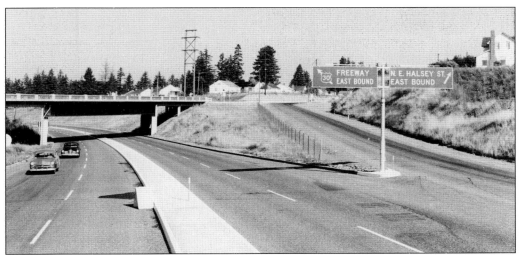

This late-1950s photograph shows the Banfield Freeway (U.S. 30) interchange with Oregon 213 (Northeast/Southeast Eighty-second Avenue) and Northeast Halsey Street. Today the Banfield is part of Interstate 84. Interstate 205 now takes the heavy north-south traffic once carried by Oregon 213. In the southbound lane, a 1949 Ford wooden station wagon and another automobile approach. (Courtesy Oregon State Archives.)

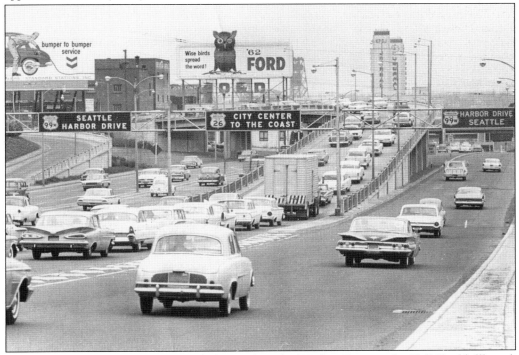

This April 3, 1962, photograph shows the south end of Harbor Drive and a 1962 Ford billboard. Harbor Drive was an expressway on the west bank of the Willamette River, completed in 1942 and removed in 1974 after plans to expand the highway ignited public opposition. By 1978, the site had been converted into a park, renamed Tom McCall Waterfront Park in 1984. (Courtesy City of Portland Archives.)

This photograph from the 1958 Portland Rose Parade shows the Union Pacific Railroad downtown office, with a sign advertising "Domeliner" passenger rail service, featuring wider windows and some elevated decks for improved views. The railroad operated the Domeliners *City of Portland*, *City of Los Angeles*, and *The Challenger* between Chicago and the Pacific Coast. The Union Pacific last offered passenger rail service in 1971. (Courtesy Oregon Department of Transportation.)

This photograph dated October 15, 1930, shows airplanes at the Rankin Airport "while construction and grading was going on," according to a note on the back of the photograph. The Rankin Airport was located off Pacific Highway near Columbia Boulevard in the late 1920s and the 1930s. (Courtesy City of Portland Archives.)

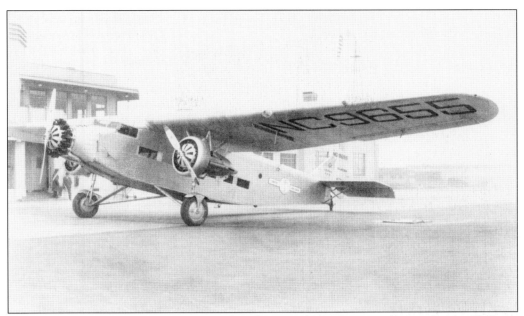

This undated photograph shows a United Airlines Ford Tri-Motor airplane at Portland's Swan Island Airport. The 256-acre Swan Island Airport was built by the Port of Portland between 1926 and 1930 and was dedicated by Charles Lindbergh in 1927. The airport was rapidly becoming outdated, so the port purchased a 700-acre site and completed the new airport by 1940. (Courtesy City of Portland Archives.)

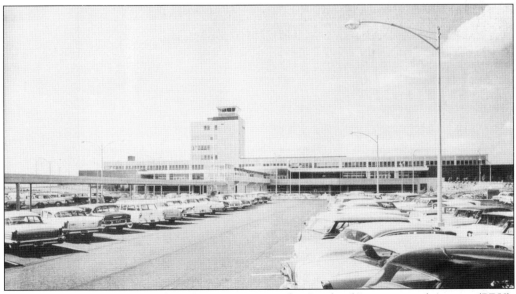

This 1959 photograph shows the new airport terminal at Portland International Airport (PDX). At that time, the airport had one 8,800-foot runway serving over 200 aircraft and 2,000 passengers each day, with a second runway under construction. Built in 1940, PDX was originally named the Portland-Columbia Airport. PDX remains at this location today, but the terminal has been extensively renovated and the runways have been lengthened. (Courtesy authors.)

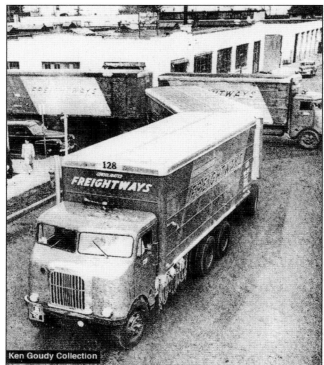

This 1954 photograph taken in Portland shows a Freightliner truck with van body belonging to Consolidated Freightways. Consolidated, begun in 1929 and based in Portland, actually started Freightliner Corporation in order to produce trucks to its own specifications. Freightliner eventually became a separate business, while Consolidated continued in trucking until going out of business in 2002. (Courtesy Ken Goudy.)

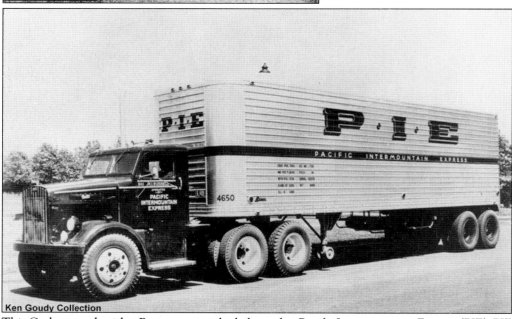

This Corbett truck with a Brown semitrailer belonged to Pacific Intermountain Express (PIE). PIE maintained a presence in Portland from the late 1950s until the early 1980s, first with facilities located at 2800 Northwest Twenty-fifth Avenue and later at 5550 North Basin Avenue. The company merged with Ryder Truck Lines in 1983, which failed after being separated from Ryder's truck rental operation. (Courtesy Ken Goudy.)

This matchbook cover advertises Oregon-Nevada-California Fast Freight, Inc. (ONC), a trucking company. The company was headquartered in San Francisco, with terminals in Oregon, Washington, California, and Nevada. Its Portland terminal was located at 1225 Southeast Water Avenue. ONC was purchased by Crouch Freight Systems sometime in the 1970s. (Courtesy authors.)

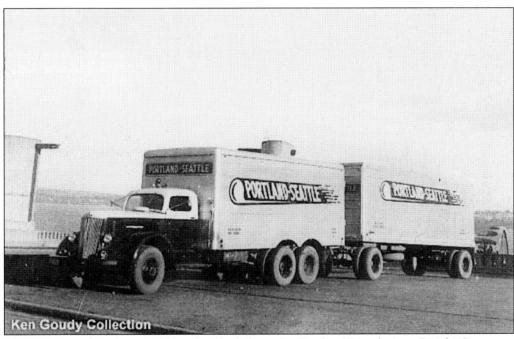

This White truck with van body and trailer belonged to Portland-Seattle Auto Freight Company. This photograph was actually taken in Seattle, Washington, at the west end of the Mercer Island floating bridge. Portland-Seattle Auto Freight occupied various locations in Portland from the 1940s until the late 1960s, closing by 1970. (Courtesy Ken Goudy.)

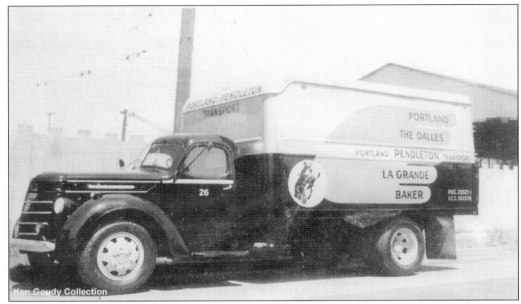

This undated photograph shows an International Model D truck with van body belonging to Portland-Pendleton Motor Freight, Inc. Serving Portland, Pendleton, LaGrande, Baker, and the Dalles, Portland-Pendleton was located at 1321 Southeast Water Avenue from the 1940s into the 1950s, closing by 1955. H. O. Sites was president of Portland-Pendleton in 1950. (Courtesy Ken Goudy.)

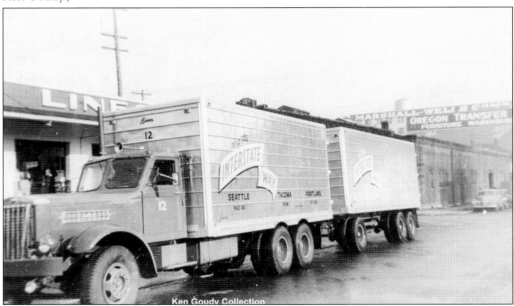

This Sterling truck with trailer belonged to Interstate Freight Lines, which served Portland, Tacoma, and Seattle, Washington. This photograph was taken in Portland with the Oregon Transfer Furniture Warehouse and Marshall-Wells Camp in the background. In the 1940s, Interstate was located at 1130 Southeast Water Avenue, moving to 905 Northwest Seventeenth Avenue by 1950 and remaining there until closing in the late 1960s. (Courtesy Ken Goudy.)

Five

PRODUCTS AND COMPANIES

Some of the most important icons of a city are the companies that do business there and the products they make and sell.

These companies employ residents in making their products, and often the products have a unique identity of their own or even a local "feel." People are often familiar with these products and feel pride in their local origins. Products such as Blitz-Weinhard beer, Sugar Crest doughnuts, Williams potato chips, Wool O' The West blankets, and Golden West coffee were once made in Portland, to name a few.

In the relentless march of mergers and globalization, many of these companies and products have vanished. With them, some of Portland's identity and character has been lost. This chapter illustrates some of these vanished products and companies.

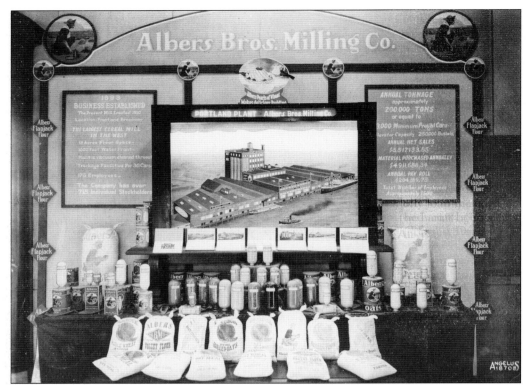

This undated photograph shows an exhibit of the Albers Brothers Milling Company. The Albers mill was located at the corner of Front Avenue and Broadway Street on the Portland Harbor beginning in 1910. Founded in 1893, the Albers mill employed approximately 1,500 workers with an annual payroll of $204,189.34. The building survives, but Albers switched to production of animal feed and moved to 15840 North Simmons Road. (Courtesy Multnomah County Library.)

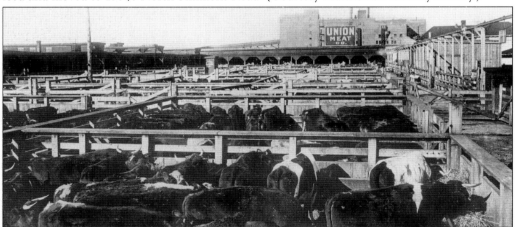

Around 1905, Swift and Company purchased 3,400 acres along the Columbia River, the Union Meat Company, and an interest in the Portland Union Stockyards Company. In 1907, Swift constructed a new packing plant, and the stockyards (seen here) grew to be the largest in a five-state area. The stockyards closed in 1988, and the exchange building was razed in 1998. (Courtesy Oregon State University Archives.)

This 1936 matchbook cover advertises the Pacific International Livestock Exposition (PI), which was held at the present site of the Portland Expo Center. The exposition was started in 1910 by Swift and Company to promote business for the nearby stockyards, and it eventually grew to be one of the largest livestock shows in the United States. The PI facilities were taken over by Multnomah County in 1965, and the livestock show moved to Hillsboro, Oregon, in 1990. (Courtesy authors.)

INDUSTRIAL SHOW

LIVE STOCK SHOW

HORSE SHOW

RODEO

Twenty Sixth Annual

1936
PACIFIC
INTERNATIONAL
LIVESTOCK
EXPOSITION
— □ —
OCTOBER 3–10, Inclusive
PORTLAND, OREGON

CLOSE COVER BEFORE STRIKING

These ladies work in the Portland Woolen Mills, with a box of the mill's trademark Wool O' The West virgin wool blankets in the background. Charles H. Carter was involved with the management of Portland Woolen Mills for many years. Portland Woolen Mills operated on West Baltimore Street in the St. Johns area for many decades, closing in approximately 1981. (Courtesy Oregon State University Archives.)

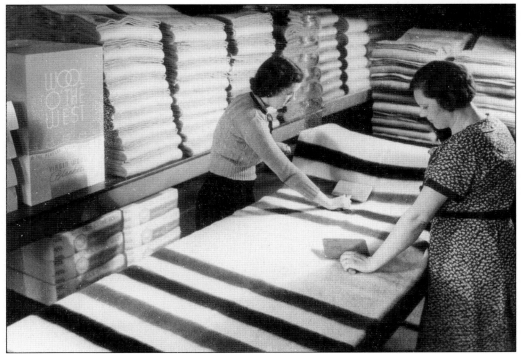

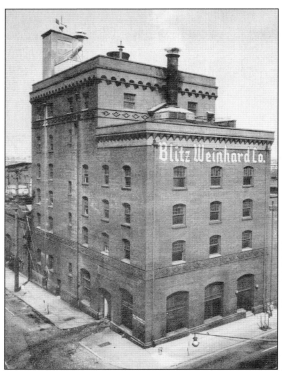

This undated photograph shows a building of the City Brewery. Founded in 1862 by Henry Weinhard, the brewery complex sprawled over portions of several blocks at Eleventh Avenue, Twelfth Avenue, Burnside Street, and Couch Street. Producers of Blitz-Weinhard beer and Henry Weinhard's Private Reserve beer, the company was purchased by Miller Brewing in 1999, and all production moved out of Portland. (Courtesy Multnomah County Library.)

This early photograph shows the unusual facility of Steigerwald Dairy Company, located at Northeast Thirty-seventh Avenue and Sandy Boulevard. Built in about 1926 and designed by architects H. L. Camp and Company, the unique milk-bottle-styled three-story building was used for the Steigerwald dairy sales business for many years. (Courtesy Nelson family archives.)

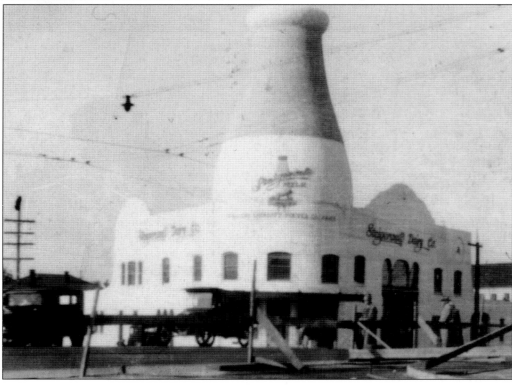

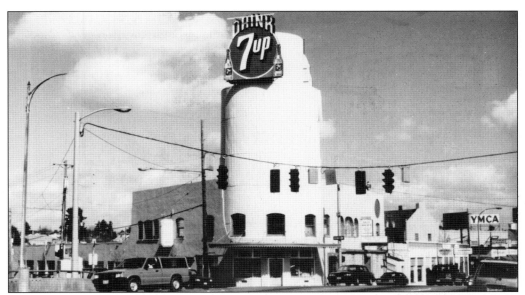

This 1990 photograph shows the former Steigerwald Dairy Company facility, remodeled as a 7-Up facility. In 1936, the Superior Roofing and Paint Company enclosed the top of the milk bottle to advertise Pabco Paint. Later 7-Up took over, and in about 2003, the 7-Up sign was replaced with the current Budweiser sign. (Courtesy Donald R. Nelson.)

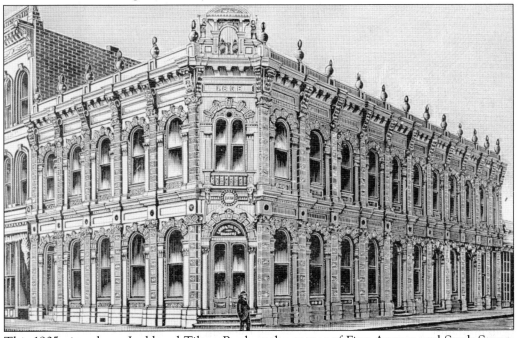

This 1905 view shows Ladd and Tilton Bank at the corner of First Avenue and Stark Street. Founded in 1859 by William S. Ladd and Charles E. Tilton, the bank was purchased by the United States National Bank in 1925. The 1868 cast-iron building was designed by architect W. A. Coolidge. The building was razed in 1954, and today the site holds a parking lot. (Courtesy Nelson family archives.)

Portland's First National Bank is seen here during the 1960s. The First National Bank of Portland was founded in 1866. Designed by W. A. Coolidge, the building was completed in 1916 at a cost of $400,000. First National became First Interstate Bank of Oregon in 1979 and was taken over by Wells, Fargo, and Company in 1996. Since 1972, the building has housed an assortment of financial institutions. (Courtesy authors.)

This undated photograph shows the First National Bank's float in a Portland Rose Parade. In the middle of the 20th century, Portland was an important lumber milling and shipping center, and this float featuring Paul Bunyan and his blue ox, Babe, celebrated Portland's connection to the timber industry. (Courtesy Oregon State Archives.)

This undated photograph shows the United States National Bank of Oregon at the corner of Southwest Stark Street and Sixth Avenue. Designed by architect A. E. Doyle and started in 1917, the massive steel and terra-cotta second-century Roman–style building was expanded in 1925. During the 1990s, the bank's branches retained the U.S. Bank name after being purchased by First Bank of Minneapolis. (Courtesy Multnomah County Library.)

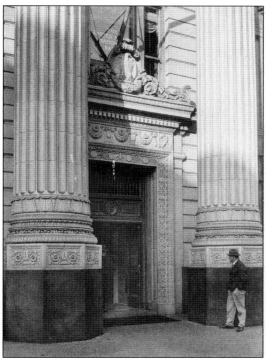

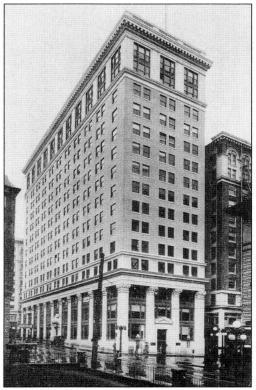

This photograph shows the Northwestern National Bank, founded in 1912 by Henry Pittock and Frederick Leadbetter. The building was designed by A. E. Doyle with Corinthian columns. On March 26, 1927, depositors received anonymous calls warning that the bank would fail. Lines formed outside the bank the morning of Monday, March 28, and by 6:00 p.m., $2 million had been withdrawn, forcing the bank into liquidation. (Courtesy Multnomah County Library.)

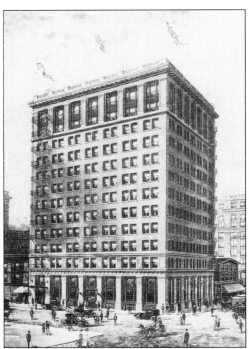

This view shows the Portland Trust and Savings Bank, located in the Spalding Building at the corner of Southwest Washington Street and Third Avenue. Portland Trust merged with the Commercial Bank of Lake Oswego, Oregon, in the 1960s, creating the Oregon Bank. In the 1970s, Oregon Bank merged with Security Bank of Oregon and was then purchased by Security Pacific Bank in the 1980s. (Courtesy Multnomah County Library.)

This early sketch shows the home of the Commercial National Bank and the Portland Savings Bank. The Commercial National Bank was purchased by Wells, Fargo, and Company during a 1890s banking panic, who renamed it the Portland branch of Wells Fargo in 1898. On June 5, 1905, the Portland branch of Wells Fargo was purchased by the United States National Bank. (Courtesy Multnomah County Library.)

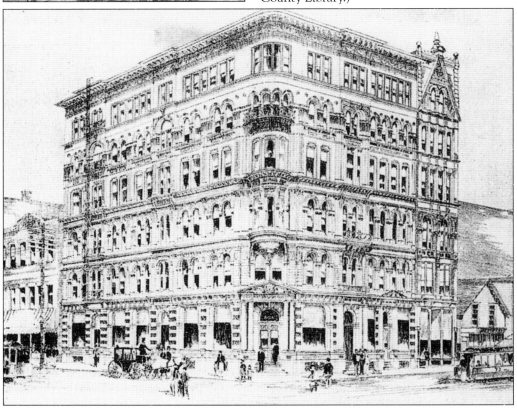

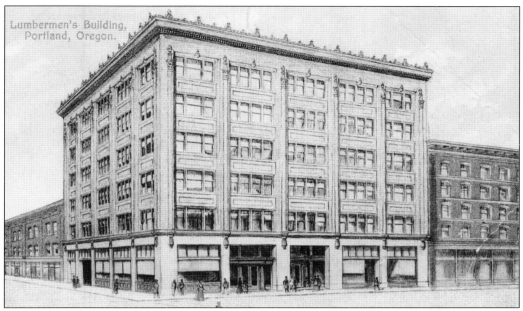

This scene shows the home of the Lumbermen's National Bank from 1909 until 1917 at the corner of Fifth Avenue and Stark Street. Founded in 1906 as the Banker's and Lumbermen's Bank, Lumbermen's purchased the West Side Branch of Geo. W. Bates and Company Bank, which had been located in the Henry Building. United States National Bank acquired Lumbermen's on September 15, 1917. (Courtesy authors.)

Portland Federal Savings operated in Portland from the 1930s into the 1970s. Portland Federal was located at the corner of Southwest Fifth Avenue and Southwest Washington Street, with branches at 1307 Northeast 102nd Avenue, Milwaukie, the Lloyd Center, 4770 Southwest Seventy-sixth Avenue, 1105 Southwest Fifth Avenue, Oregon City, and 8135 Southwest Division Street, and a regional loan agency in Salem. (Courtesy authors.)

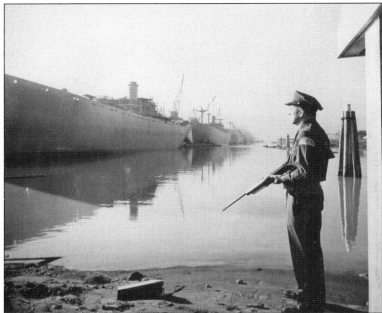

This photograph shows a guard at Swan Island shipyard. On March 16, 1942, ground was broken for the Kaiser shipyard on Swan Island, which delivered its first ship on December 31, 1942. Specializing in T2 oil tankers, Kaiser delivered 134 T2s before the end of World War II and built more tankers than any other yard for 12 out of 15 months until the end of 1944. (Courtesy Dusty Schmidt.)

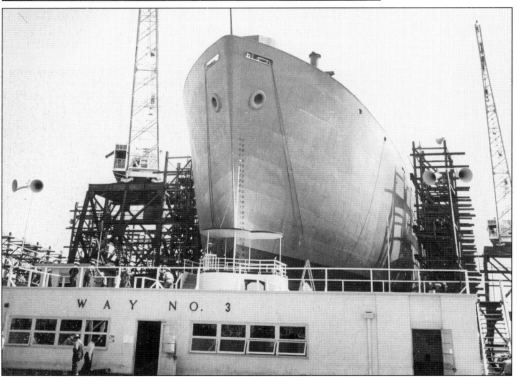

The $23-million Kaiser yard on Swan Island boasted eight shipways. A T2 tanker is being completed on way number three in this undated photograph. The Port of Portland purchased the shipyard after the war and operated it as a ship repair facility, selling the yard to Cascade General, Inc., in 1999. Cascade continues to operate the yard as a repair facility. (Courtesy Michael Fairley.)

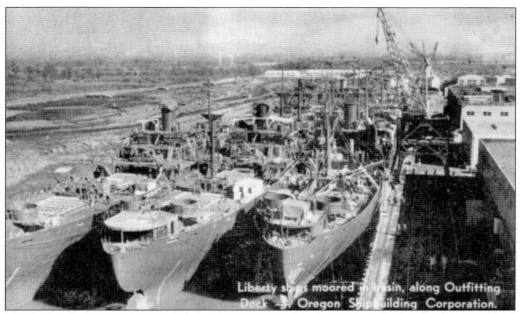

Liberty ships moored in basin, along Outfitting Dock — Oregon Shipbuilding Corporation.

This undated photograph shows Liberty ships being outfitted at Oregon Shipbuilding Corporation, a Kaiser company, which started on the east bank of the Willamette River at St. Johns early in 1941. This shipyard specialized in Liberty ships and by December 31, 1944, had built 330 Liberty ships, 48 Victory ships, and 30 Attack Transports. During 1944, Oregon Shipbuilding built more attack transports than any other yard. (Courtesy Dusty Schmidt.)

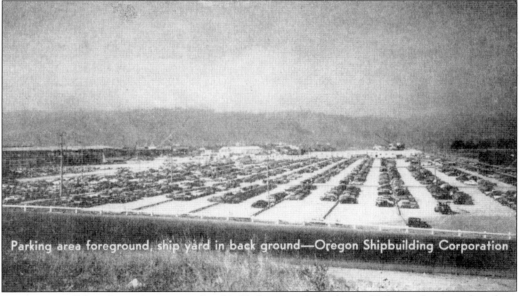

Parking area foreground, ship yard in back ground—Oregon Shipbuilding Corporation

An immense labor force was required to build the record numbers of Liberty ships produced at Oregon Shipbuilding Corporation, as shown by this photograph of the yard's employee parking area. By July 17, 1941, the yard employed 2,500 workers and had 11 shipways and 5 keels laid, less than two months after the first keel was laid and just five months after ground-breaking for the yard. (Courtesy Dusty Schmidt.)

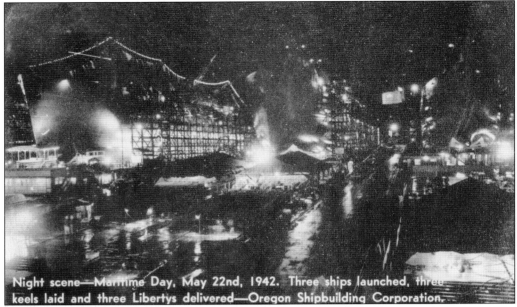

Night scene—Maritime Day, May 22nd, 1942. Three ships launched, three keels laid and three Libertys delivered—Oregon Shipbuilding Corporation.

This May 22, 1942, photograph illustrates the fact that the wartime shipyards were 24-hour operations. Oregon Shipbuilding Corporation was rightly proud of their production accomplishments, just six months after the start of World War II having laid three keels, launched three ships, and delivered three Liberty ships on that day. (Courtesy authors.)

The Willamette Tug and Barge Company's dredge *J. H. Polhemus* is at work. Willamette Tug and Barge operated from the 1930s into the 1970s, offering towing, barging, dredging, pile driving, heavy lifts, sand and gravel, crushed gravel, and ready-mix concrete. James H. Polhemus was the company's treasurer in 1960 and had been the president of Portland General Electric in the 1940s. (Courtesy Dusty Schmidt.)

This 1973 photograph shows a structure being built with Willamette Industries lumber overlooking Portland and a view of Willamette Industries' corporate headquarters. Willamette Valley Lumber Company, the predecessor of Willamette Industries, was founded in 1906 in Dallas, Oregon, and maintained offices in Portland continuously, starting between 1907 and 1909. In 2002, Willamette Industries was purchased by Weyerhauser of Federal Way, Washington, for approximately $6.1 billion. (Courtesy Multnomah County Library.)

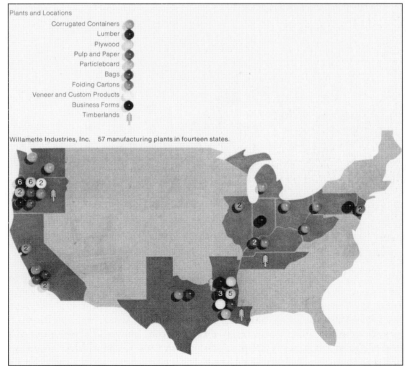

This 1978 map shows both the geographical extent of Willamette Industries' operations and the range of products produced. At that time, Willamette Industries had 57 facilities in 14 states, producing lumber, plywood, and a wide variety of paper products. In 2002, when Weyerhauser took over, Willamette owned 1.73 million acres of timberland. (Courtesy Multnomah County Library.)

This undated photograph shows the production line in the Fir-Tex Insulating Board, Inc., plant. Fir-Tex was headquartered in Portland and operated during the 1940s and 1950s, producing an interior finish panel made from wood fibers. The company and 15,000 acres of timberland was purchased by Kaiser Gypsum Company for $8 million in 1956. (Courtesy Oregon State University Archives.)

This artist's rendering shows the corporate headquarters for Georgia-Pacific Corporation. Construction began on the two-building complex, located between Southwest Third and Fifth Avenues and Taylor and Salmon Streets, in 1967. The complex included a 29-story, 540,670-square-foot international headquarters office building, Oregon's tallest building, and an eight-story parking garage with underpass tunnel. Georgia-Pacific moved its headquarters to Atlanta, Georgia, in 1982. (Courtesy Multnomah County Library.)

This 1993 photograph shows an exhibit of Louisiana-Pacific Corporation's extensive product line at the National Association of Homebuilders annual convention. A court-ordered breakup of some of Georgia-Pacific's assets created Louisiana-Pacific Corporation in 1973, with headquarters in Portland and Harry Merlo in charge. Louisiana-Pacific moved its corporate headquarters to Nashville, Tennessee, in 2004. (Courtesy Multnomah County Library.)

This photograph shows a Golden West Coffee box from the early 1940s. Golden West Coffee was sold by Clossett and Devers, Inc., located at the corner of Northwest Fifteenth Avenue and Pettygrove Street. Clossett and Devers was in business at least from 1931 into the 1950s. Clossett and Company, coffee roasters and importers of green coffees located at 1617 Northwest Fourteenth Avenue, offered "Monogram" coffee. (Courtesy Donley Bottenberg.)

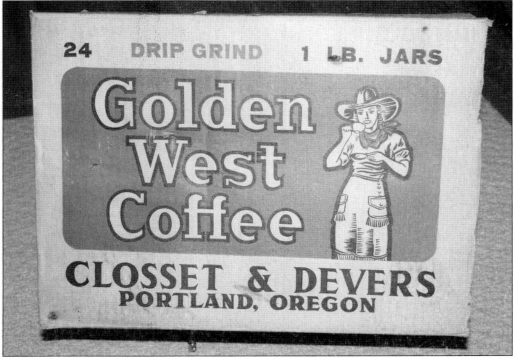

This matchbook cover advertises Portland Rose pipe tobacco, sold by the Arthur Leonard pipe and tobacco shop. The Arthur Leonard store was in business approximately from the 1940s into the 1980s, with an additional site at the Lloyd Center. In 1970, the Arthur Leonard store was operated by Louis A. Leonard. (Courtesy authors.)

This matchbook cover advertises Hudson House canned foods, produced by Hudson and Duncan, Inc. Located at 325 Southeast Water Avenue, Hudson and Duncan was in operation approximately from the 1930s into the 1950s. Hudson and Duncan also operated a bakery at 585 East Stark Street. In 1931, Robert A. Hudson was the firm's president and J. H. Duncan was its vice president. (Courtesy authors.)

94

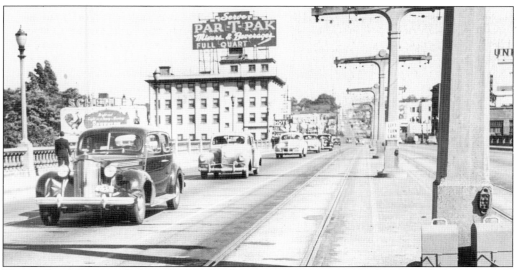

This undated photograph shows Par-T-Pak, a beverage and mixer store at the east end of the Burnside Bridge, and a Schenley Whiskey sign. Note the poles and rails at the center of the bridge deck. They were for the streetcars that crossed the Burnside Bridge. By the time of this photograph, in the 1940s, rubber-tired electric buses plied the same route to the east side. (Courtesy City of Portland Archives.)

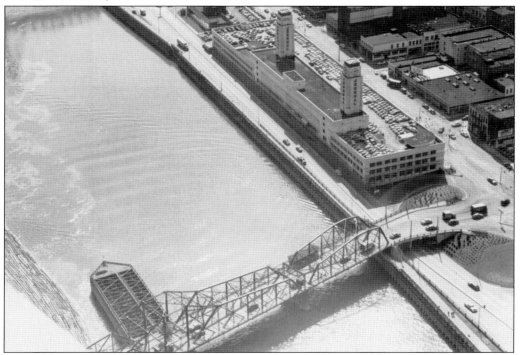

This 1952 aerial view shows the *Oregon Journal* building, between Harbor Drive and Front Avenue, with the Morrison Bridge in the foreground. Originally owned by C. S. Jackson, the *Oregon Journal* was Portland's afternoon daily newspaper from 1902 until 1982. The paper was sold to the *Oregonian* in 1961. (Courtesy City of Portland Archives.)

This 1957 photograph taken at Northeast Glisan Street and Thirty-ninth Avenue shows a bench located in a traffic island, advertising Sugar Crest doughnuts. Today the bench would be considered a safety hazard. One of Sugar Crest's many well-remembered products was a frosted doughnut with sliced almonds along the sides. (Courtesy City of Portland Archives.)

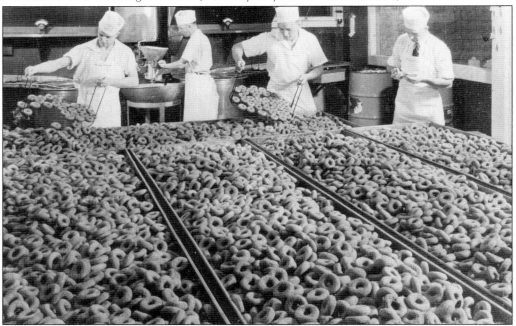

Here are workers on the production line of the Sugar Crest Doughnut Company. The Sugar Crest Doughnut Company was in operation at least from the 1930s to the late 1950s. Their doughnuts are reported to have been far superior to the products of today's popular brands. (Courtesy Oregon State University Archives.)

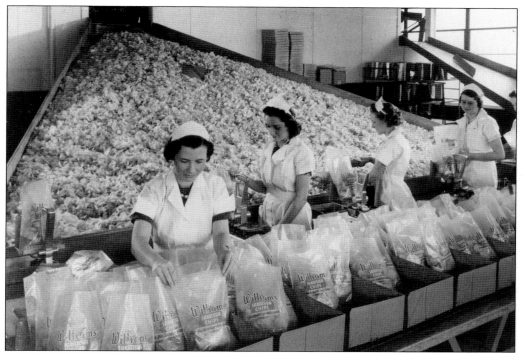

Ladies bag Saratoga potato chips at the Williams Potato Chip Company. The company appears to have faded into obscurity, forcing modern Portlanders who crave potato chips to buy national brands or choose from several specialty brands made in the Pacific Northwest. (Courtesy Oregon State University Archives.)

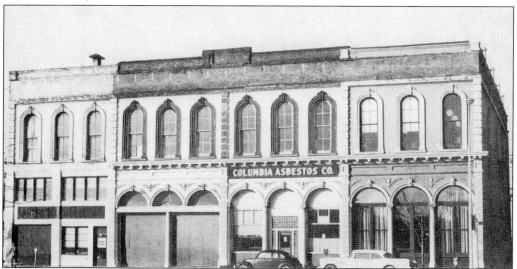

This undated photograph shows the Columbia Asbestos Company, located at 111 Southwest Front Avenue. Columbia Asbestos Company produced asbestos industrial insulation and provided installation services. The company was in business approximately from the 1950s into the 1970s. Presumably the market for asbestos products was affected by the increasing attention toward the health risks of asbestos. (Courtesy Multnomah County Library.)

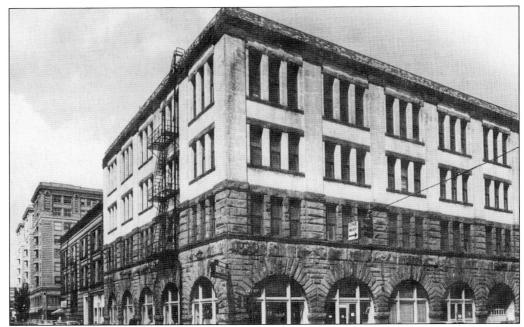

This photograph shows the Richardson Romanesque–style store of J. E. Haseltine and Company at the corner of Southwest Second Avenue and Pine Street, built in 1893. J. E. Haseltine bought a half interest in the E. J. Northrup and Company hardware business in 1883, renaming the firm J. E. Haseltine and Company in 1897. Haseltine operated as a primarily wholesale hardware dealer until approximately the 1970s. (Courtesy Multnomah County Library.)

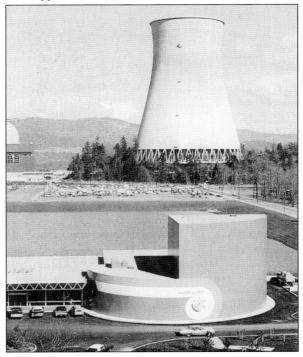

This undated photograph shows the cooling tower of the Trojan Nuclear Plant, with part of the reactor visible to the left and its visitor center in the foreground. Owned by Portland General Electric Company and completed in 1975, the plant provided 1.13 million kilowatts of generating capacity. Trojan was demolished in a dramatic implosion on May 21, 2006. (Courtesy authors.)

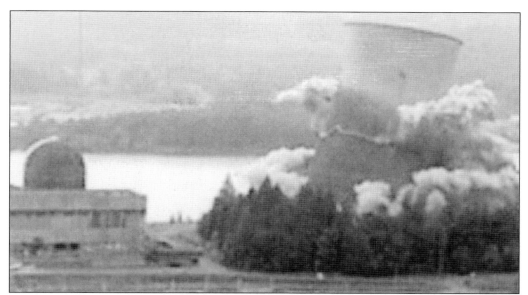

On May 21, 2006, the Trojan nuclear power plant, belonging to Portland General Electric Company, imploded. The Trojan nuclear power plant, located at St. Helens, Oregon, was for many years a landmark. In later years, it became the target of several Oregon ballot initiatives attempting to outlaw it. Eventually operational problems led to its decommissioning and demolition. (Courtesy Portland General Electric Company.)

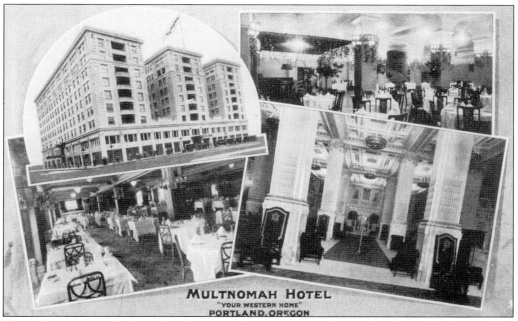

MULTNOMAH HOTEL
"YOUR WESTERN HOME"
PORTLAND, OREGON

This advertising card shows the American Renaissance–style Hotel Multnomah, designed by architect Frank B. Gibson and built in 1912 on Southwest Pine Street between Third and Fourth Avenues. The Multnomah boasted 600 outside rooms and was Portland's largest hotel until 1961. From 1965 to 1992, the building housed government offices, and after a $60-million restoration, it currently houses the Embassy Suites Hotel. (Courtesy authors.)

This undated photograph shows the City Center Motel, located in the Hollywood district midway between the Lloyd Center and the Portland Airport at 3800 Northeast Sandy Boulevard. The City Center Motel offered all-color television, blackout drapes for assured sleep, and direct-dial telephones. Currently the site houses the Rodeway Inn Midtown Motel. (Courtesy authors.)

The Sheraton Hotel was located within the Lloyd Center shopping mall at 1000 Northeast Multnomah Street. Offering a swimming pool with cabanas, free parking, and the Kon-Tiki restaurant, the Sheraton was air-conditioned in all rooms. The building later became a Red Lion facility and is currently a Doubletree Inn. (Courtesy authors.)

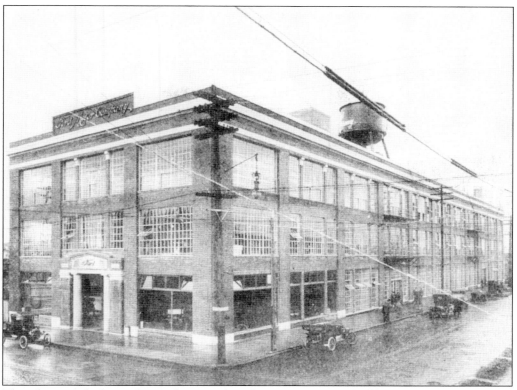

This photograph shows the newly opened Ford Motor Company building, located at Southeast Eleventh Avenue and Division Street. This facility opened in 1914 and was used as an assembly plant for Model Ts from 1914 to 1918 and 1923 to 1927, Model As from 1928 to 1930, and the Ford V8 from 1932 to 1934. Ford left the site by 1940. (Courtesy Multnomah County Library.)

This unused letterhead shows the building of Francis Motor Car Company, located on Southeast Grand Avenue between Hawthorne Boulevard and Madison Street. Founded in 1913 by C. E. Francis and later known as Francis Ford, the company sold Model T Ford automobiles, Lincoln automobiles, and even Fordson tractors in the 1920s. (Courtesy authors.)

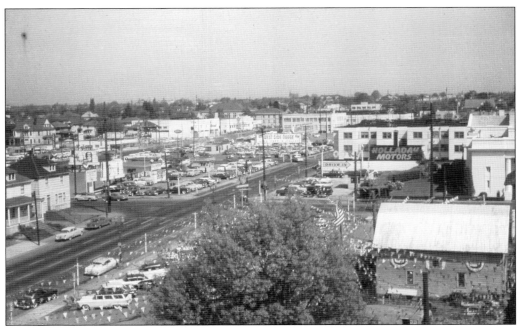

This photograph from the 1950s shows the concentration of automobile dealerships on Grand Avenue. Francis Ford, Holladay Motors, West Side Dodge (ironically located on the east side of town), and other unidentified automobile dealerships are visible. Today similar concentrations of automobile dealerships can be found much farther east. (Courtesy Nelson family archives.)

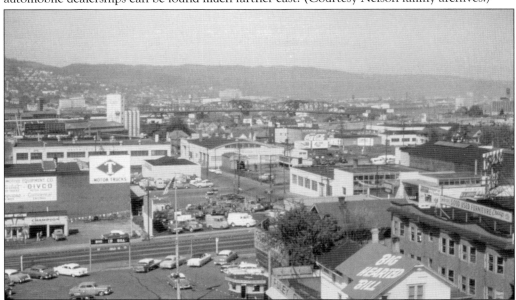

This 1950s photograph shows a number of automobile and truck-related businesses located near Grand Avenue. Wentworth and Irwin, which offered GMC trucks and their own line of trailers; "Big Hearted Bill;" and Automotive Equipment Company, which offered Diamond T trucks, Peterbilt trucks, Divco trucks, Continental engines, and Firestone tires, are visible. Other signs offer used furniture and Coca-Cola. (Courtesy Nelson family archives.)

Six

SPORTS, ARTS, ENTERTAINMENT, AND MEDIA

Portland once had a theater district on Southwest Broadway Street with numerous grand theaters with pipe organs dating from before talking movies. While they easily adapted to the talking movies, over the years, the processes of change slowly eliminated them, except for the Paramount. The Paramount survives as the Arlene Schnitzer Concert Hall after renovation by the City of Portland.

The Jantzen Beach amusement park is surely remembered by many Portlanders. Open from 1928 to 1970, Jantzen Beach included swimming pools, the "Big Dipper" roller coaster, picnic grounds, thrill rides, midway games, midget auto racing, a carousel, a Ferris wheel, and a ballroom. Jantzen Beach was replaced by a shopping center.

Children of the 1950s might remember Heck Harper and Rusty Nails, hosts of children's shows, and surely many children of the 1960s through 1990s remember the *Ramblin' Rod* children's show. Their parents (and many of the children themselves) probably remember *Portland Wrestling*. The highlight of Portland sports was surely the 1977 NBA championship won by the Portland Trail Blazers. While the Trail Blazers survive, the Portland Storm football team and the Portland Buckaroos hockey team have vanished.

This chapter illustrates these and more memories.

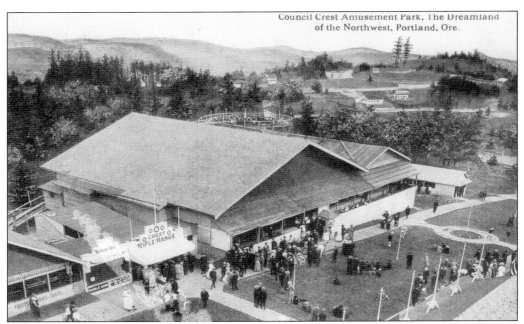

Portland's Council Crest Amusement Park was named for its location, Portland's highest point at 1,073-foot elevation, and provided views of the city, the Willamette and Columbia Rivers, and Mount Rainier, Mount St. Helens, Mount Adams, and Mount Hood. Council Crest Amusement Park opened in 1907 and closed in 1929, and today the site holds Council Crest Park. (Courtesy Linda and Dale Renk.)

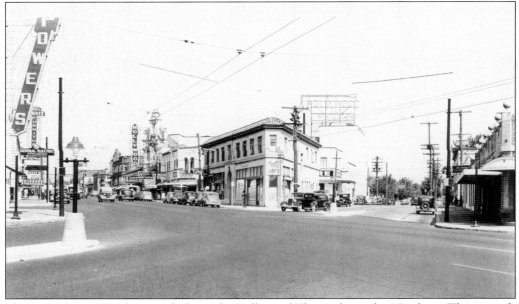

This August 14, 1939, photograph shows the Hollywood Theater located at Northeast Thirty-ninth Avenue and Sandy Boulevard. The Hollywood Theater was in business from 1926 into at least the 1980s. Managers were Willard A. Coghlan in 1940, R. M. Hopkins in 1950, Carl W. Miller in 1960, and Martha J. Moll in 1980. (Courtesy City of Portland Archives.)

This undated photograph shows the sign of the Paramount Theater on Southwest Broadway Street near Columbia Street. The theater opened in 1928 as the Portland Publix Theater, a vaudeville venue, changing to the Paramount in 1930 when the owners received a contract to show Paramount films locally. The city acquired the theater in the early 1980s and renovated it, creating the Arlene Schnitzer Concert Hall. (Courtesy City of Portland Archives.)

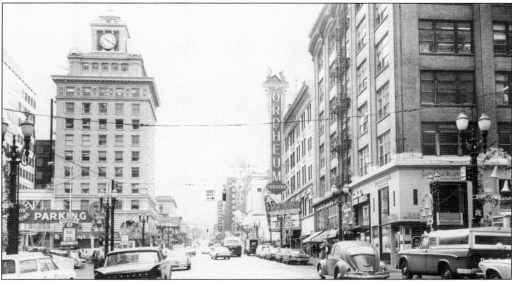

The Orpheum Theater, on Broadway near Morrison Street, opened in 1913 as the Empress Theatre, changed to the Hippodrome in 1917, and was remodeled by architect B. Marcus Priteca in 1926 for Pantages. The theater operated as the Orpheum Theatre from 1929 until the mid-1970s, when it was razed to make room for a Nordstrom clothing store. (Courtesy City of Portland Archives.)

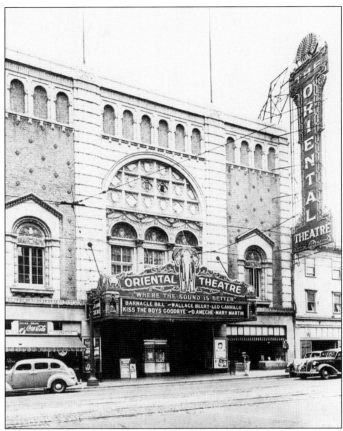

This undated photograph shows the Oriental Theatre, located near the corner of Southeast Morrison Street and Grand Avenue. Designed by architects Thomas and Mercier and built in 1928, the Oriental sports a "Far East" theme, with Buddha and elephant statues, and what was billed as the tallest neon sign on the West Coast. The Oriental was razed in 1970 to make room for a parking lot. (Courtesy Multnomah County Library.)

The Broadway Theater was located at 1008 Southwest Broadway Street. Built by J. J. Parker in 1926, the Broadway featured 1,832 seats and a corner marquee to protect patrons from the rain Portland is well known for. The Broadway Theater was closed in 1988. (Courtesy Multnomah County Library.)

This undated photograph shows the Fox Theater with the Paramount Theater in the background. The marquee advertises *From Russia With Love*, a James Bond film starring Sean Connery. Across the street, a portion of a sign is visible, believed likely to be the sign for the Whistlin' Pig restaurant. (Courtesy Mark Moore.)

Shown in this 1937 postcard is the Imperial Roller Rink, located on Southeast Madison Street near Grand Avenue. The card boasted of several hundred pairs of new skates, a new pipe organ, and operating hours of 7:00 to 11:30 p.m. The Imperial was in operation approximately from the 1940s into the 1970s. Currently the facility houses an indoor soccer facility under the Morrison Bridge. (Courtesy Linda and Dale Renk.)

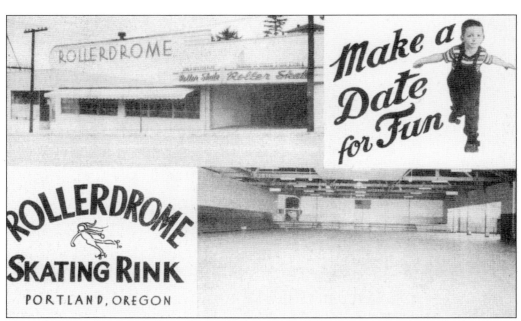

This advertising postcard shows the Rollerdrome, a roller-skating rink. The Rollerdrome was located at 5227 Northeast Sandy Boulevard and was in operation approximately from the 1930s into the 1940s. Roller-skating was quite popular at that time, and roller rinks typically included a pipe organ. (Courtesy Linda and Dale Renk.)

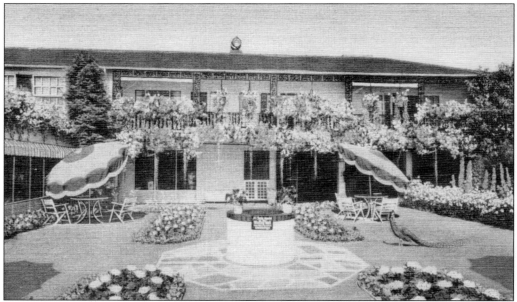

This undated view shows the wishing well at Lambert Gardens. Operated by Andrew B. Lambert and Lilybel Gresham, Lambert Gardens was in operation approximately from the 1930s into the 1970s at 5120 Southeast Twenty-eighth Avenue. Lambert Gardens boasted "10 separate gardens on 30 acres, exotic rare birds, flowers and pools." Large apartment complexes have occupied the site for several decades. (Courtesy City of Portland Archives.)

This early postcard shows the characters of the radio show *Covered Wagon Days*, which was broadcast on KGW. While KGW remains an important Portland television and radio station, *Covered Wagon Days* has long since vanished, and sponsor Gevurtz Furniture moved from its longtime home on Southwest Morrison Street to Tigard, Oregon, in 1984 and went out of business in 1997. (Courtesy Dusty Schmidt.)

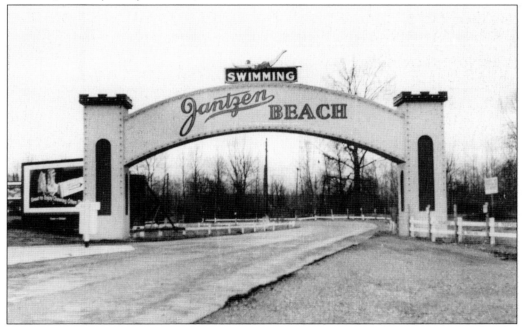

This photograph shows the entrance gate to Portland's Jantzen Beach Amusement Park. The park opened in 1928, featuring swimming pools, the Big Dipper roller coaster, a picnic grounds, thrill rides, midway games, midget auto racing, a carousel, a Ferris wheel, and a ballroom. The park closed in 1970 and was replaced by a shopping center. (Courtesy Mark Moore.)

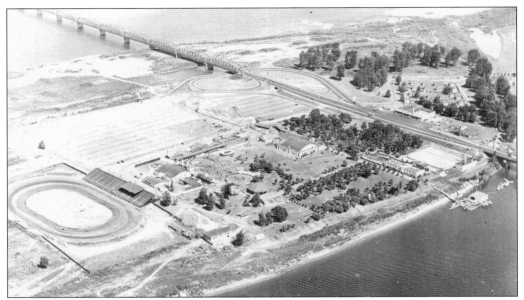

This 1950 aerial scene shows the Jantzen Beach amusement park and the Interstate Bridge. The Big Dipper roller coaster is visible along with many of the other attractions. The swimming pool at right was lost when the Interstate Bridge was expanded in 1958. Jantzen Beach also included a restaurant called Elbow Room, opened in 1937. (Courtesy City of Portland Archives.)

This undated card promotes KPTV's *Ramblin' Rod Show*, a very popular children's show featuring Popeye and Looney Tunes cartoons and a smile contest for the young guests. From 1964 to 1997, the show was hosted by Rod Anders, who was known for entering and leaving the set on a tugboat prop and for his sweater covered in buttons given by guests. (Courtesy Gholston Collection.)

KATU television children's show host Rusty Nails, also known as Jim Allen, visited the Story Book Lane at Alpenrose Dairy, 6149 Southwest Shattuck Lane. Rusty's cartoon show was on the air with various stations from 1957 to 1972. Rusty went on to host KPTV's *Kids' Comedy Theater* on Saturdays. (Courtesy Mark Moore.)

This undated card shows KGW television children's show host Heck Harper on his horse Jody. On the air from 1953 to 1956, Harper was the "foreman" of the Bar 27 Corral, and the young guests were the "ranch hands." The show included Western-themed stories, singing and guitar playing by Harper, and a song for children visiting the show on their birthday. (Courtesy Mark Moore.)

Portland's Western Hockey League team was known as the Portland Buckaroos from 1960 through 1975. The Buckaroos played in the newly built Memorial Coliseum and managed to win the league championship in 1961 under coach Hal Laycoe by defeating the Seattle Totems. The Buckaroos won another championship under Laycoe in 1965 and a third in 1971 under coach Gord Fashoway. (Courtesy Dusty Schmidt.)

Beginning in 1933, the Portland area enjoyed greyhound racing at the Multnomah Kennel Club, illustrated on this 1968 racing form. During the 1980s and 1990s, greyhound racing attracted daily attendance exceeding 20,000 fans. The facility, at Northeast 223rd Avenue and Halsey Street, closed in 2004. A $400-million hotel, casino, and entertainment center is planned for the site, subject to 2008 Oregon voter approval of the casino. (Courtesy authors.)

1968 PORTLAND BEAVERS

Compliments *AVIS* RENT A CAR

This 1968 Portland Beavers baseball team photograph shows the season's players. Seated fifth from the right on the bench is Lou Piniella, who played for the Pacific Coast League team in 1966, 1967, and part of 1968 before moving to the American League. Piniella turned up in Seattle in 1992 to manage the Seattle Mariners for about 10 years. (Courtesy authors.)

This July 24, 1974, certificate celebrates the inaugural game of the Portland Storm football team. The Storm moved from New York to be Portland's World Football League (WFL) team, earning a 7-12-1 record (eighth in the 12-team league) before the Internal Revenue Service impounded the team. Portland got another team for 1975, the Portland Thunder, which lasted until the WFL folded later that season. (Courtesy Nelson family archives.)

Official Inaugural Game Certificate

July 24, 1974
Portland Storm vs. Chicago Fire
Civic Stadium

This document certifies your attendance at the Inaugural Game of the Opening Season of the World Football League and is presented with our congratulations, appreciation and best wishes

Seen here is the legendary Portland Trail Blazers coach Jack Ramsay. Coming to Portland for the 1976 and 1977 season from the Buffalo Braves, in his first year at Portland, Ramsay guided the Trail Blazers to the NBA championship. Jack Ramsay continued as the Trail Blazers coach until 1986. (Courtesy authors.)

This undated photograph shows the "voice of the Trail Blazers" from 1970 through 1998, announcer Bill Schoneley. Schoneley, an ex-marine who popularized Portland's "Rip City" battle cry, also had television and radio sports shows. Sports director of KVI Radio in Seattle before coming to Portland, Schoneley also had announced for the Oakland Seals, a National Hockey League team, and the Seattle Pilots of the American Baseball League. (Courtesy authors.)

This photograph shows Portland Trail Blazers star Bill Walton, who played center and wore number 32. Walton was an important part of the 1976–1977 season and the Trail Blazer NBA championship. In 1979, Walton became a free agent and left the Trail Blazers for the San Diego Clippers. (Courtesy authors.)

This 1980 photograph shows Portland wrestler "Rowdy" Roddy Piper, whose trademark was a Scottish kilt. *Portland Wrestling* was first shown on KPTV in 1953, leaving for KOIN only to return in 1967. Declining ratings in the 1980s and the bankruptcy of longtime sponsor Tom Peterson's furniture store led KPTV to cancel the program in 1991. (Courtesy authors.)

This 1980 photograph shows a *Portland Wrestling* match between "Playboy" Buddy Rose and another wrestler. A popular 11:00 p.m. Saturday night program on KPTV for many years, *Portland Wrestling* featured popular wrestlers such as "Rowdy" Roddy Piper, "Playboy" Buddy Rose, and Jesse "The Body" Ventura, later governor of Minnesota. (Courtesy authors.)

This photograph shows the album *Quarter Flash* by the Portland band Quarterflash. The bands Seafood Mama and Pilot merged to form Quarterflash in 1980. The lead singer and saxophonist was Rindy Ross, and the other band members were Marv Ross, Jack Charles, Rich Gooch, Rick Digiallonardo, and Brian David Willis. Best known for their song "Harden My Heart," the group disbanded in 1985 and reunited in 1990 and 1991. (Courtesy Karin Johnson.)

Seven

OREGON CENTENNIAL EXPOSITION

The 1959 Oregon Centennial Exposition was a fair celebrating Oregon's history while looking toward the future. Oregon wanted to show the world its proud history, its position as a forest products industry leader, and its eye on the future.

Located at the Pacific International Livestock Exposition grounds, now known as the Multnomah County Exposition Center, the exposition operated on a $2.6-million budget. The exposition included many exhibits, such as a home of the future and a General Motors concept car, and managed to attract entertainers such as Hank Snow, Harry Belafonte, Art Linkletter, Roy Rogers, Dale Evans, the Sons of the Pioneers, the Ice Capades, the International Water Follies, and the Japanese Takarazuka Kabuki Dancers. At Lake Oswego, there was an extensive program of water shows, including boat races and water-skiing demonstrations.

Will there be such a celebration for the Oregon Sesquicentennial, approaching in 2009?

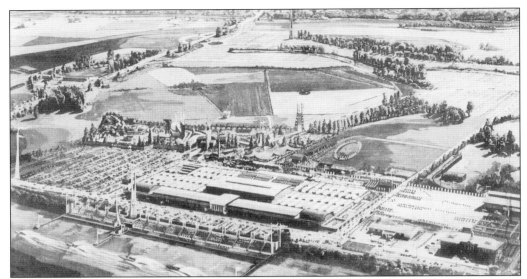

This artist's conception of the 1959 Oregon Centennial Exposition looking toward the southeast shows the site of the exposition, which was held at the Pacific International (PI) Livestock Exposition grounds. The PI buildings are in the center foreground, with the former site of Vanport City beyond and U.S. Route 99 across the upper left. (Courtesy authors.)

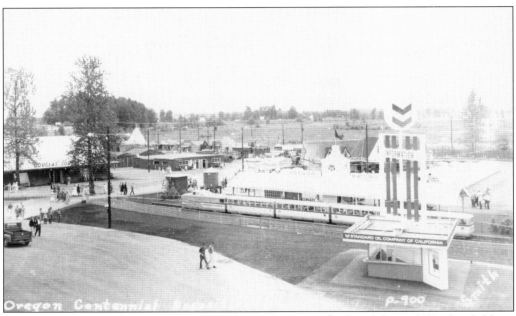

Admission to the 1959 Oregon Centennial Exposition was $1 for adults and 50¢ for children, with a 50¢ charge for parking in the exposition lot and free shuttle service to the exposition. Most exhibits were free, but Frontier Town charged 25¢ admission, Aqua Theatre charged $1 admission for adults and 50¢ admission for children, and arena shows charged varying admission. (Courtesy City of Portland Archives.)

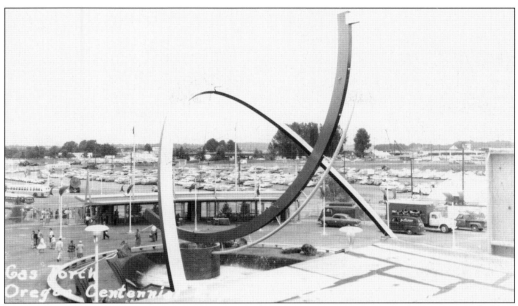

This photograph shows the "fire sculpture" at the 1959 Oregon Centennial Exposition, held at Pacific International. The fire sculpture consisted of a 50-foot tower rising from a circular pool of water, with a 40-foot-high flame, which was to burn for the entire 100 days of the exposition. (Courtesy City of Portland Archives.)

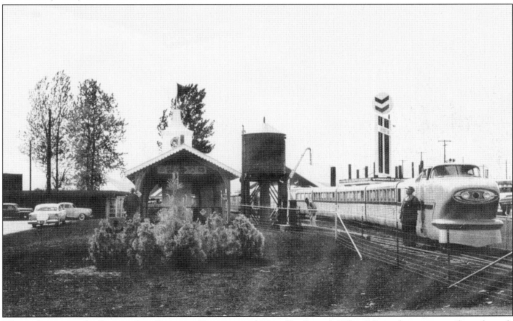

This photograph shows the Oregon Centennial Zoo Railroad. The 30-inch-gauge railroad took passengers on a 15-minute ride winding around the exposition past the Indian Village, Frontier Village, the Theater, and the Portland General Electric Building, and back to the station. The railroad cost approximately $275,000, financed primarily by railroads operating in Portland. (Courtesy City of Portland Archives.)

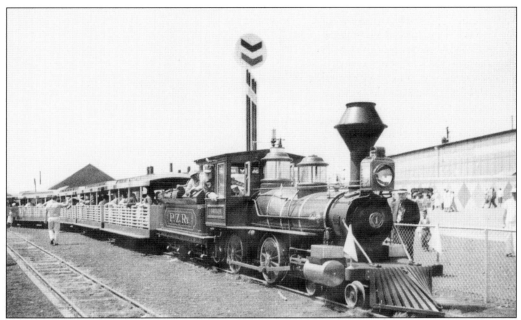

This photograph shows a replica 1870–1875 steam locomotive running on the 30-inch-gauge tracks at the Oregon Centennial Exposition. This locomotive was built by the Oregon Locomotive Builders Association at the Northern Pacific terminal roundhouse and is a replica of the Virginia and Truckee locomotive *Reno*. (Courtesy City of Portland Archives.)

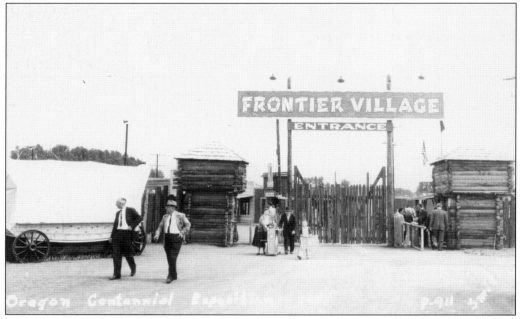

The popular Frontier Village attraction at the 1959 Oregon Centennial Exposition was billed as "an authentic re-creation of a western town of the '70s" with dance halls, a livery stable, a saloon, a post office, a hotel, gun play, a bank robbery, and dance hall girls. (Courtesy City of Portland Archives.)

This photograph shows a portion of the popular Frontier Village section of the Oregon Centennial Exposition. At that time, Western movies and Western television shows were popular, and Frontier Village enabled visitors to see Oregon's frontier history in the context of the Westerns they enjoyed. (Courtesy City of Portland Archives.)

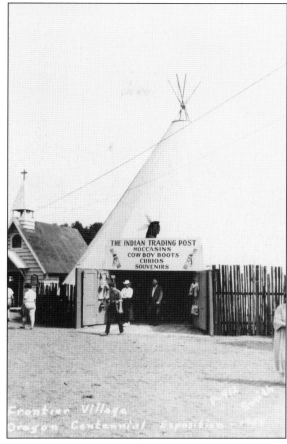

This photograph shows Tomorrow Land at the 1959 Oregon Centennial Exposition. The structure in the center is the Lumber Industry Pavilion, which was designed to show the freedom of expression possible in wood construction. The vertical logs in front of the structure are part of the lumber industry exhibit. (Courtesy City of Portland Archives.)

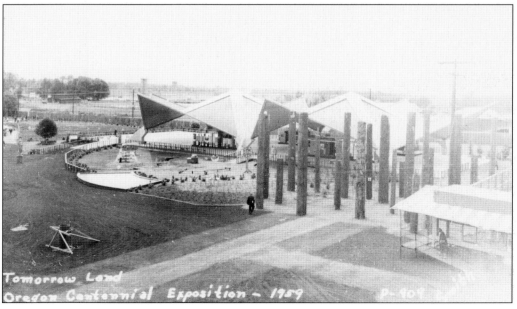

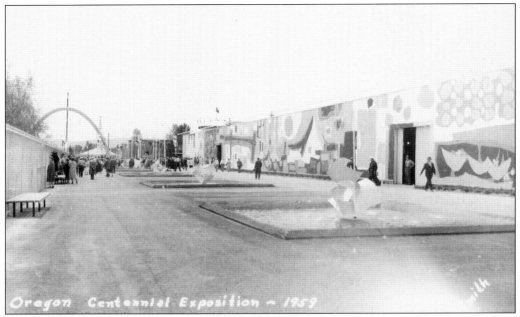

This photograph shows the east plaza of the 11-acre Pacific International Exposition building. Featured is a vivid 510-foot mural by Hamsen Associates, which covers the entire east wall of the building. The artist for the murals was Carl Morris, who painted the murals in six weeks. (Courtesy City of Portland Archives.)

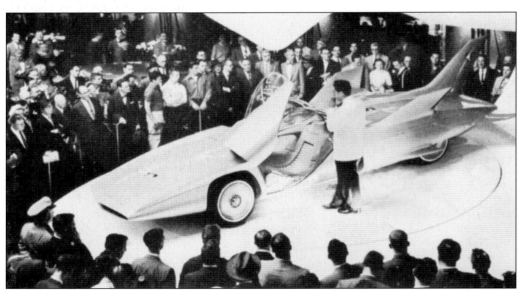

This photograph shows the Firebird III in the General Motors Motorama exhibit at the Oregon Centennial Exposition. The Motorama exhibit included 50 General Motors exhibits and covered 20,000 square feet. The exhibit included diverse General Motors products, even from their Frigidaire division, which were displayed in "Frigidaire's Futuristic Kitchen." (Courtesy authors.)

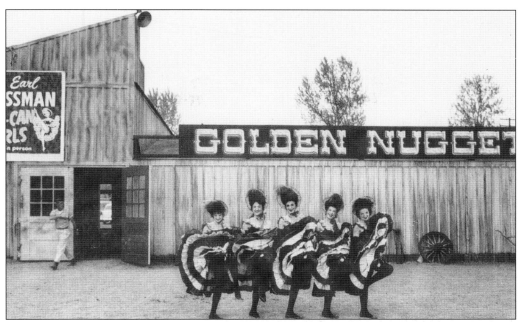

Earl Mossman's Can Can Dancing Girls in costume were consistent with the theme of Frontier Village. The Can Can Dancing Girls were the daily highlight of entertainment at Frontier Village. Also appearing with the Can Can Dancing Girls were the "Centennial Sweethearts," otherwise known as the Whipporwills. (Courtesy authors.)

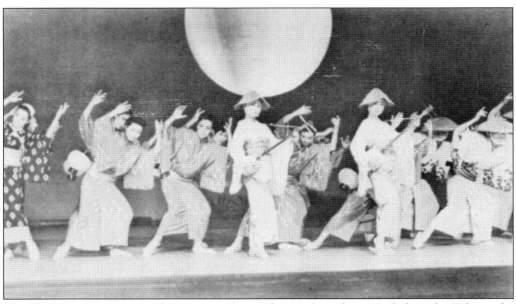

The 1959 Oregon Centennial Exposition featured a number of acts, including the Takarazuka Kabuki Dancers, shown in this photograph. The Takarazuka Kabuki Dancers, a Japanese troupe of 60 dancers, played at the Oregon Centennial Exposition from August 24 through August 29, 1959, providing a show of "spectacular beauty." (Courtesy authors.)

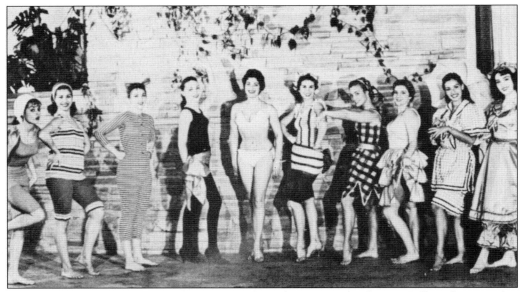

Another act featured at the Oregon Centennial was the International Water Follies, shown in this photograph. The International Water Follies was a water show featuring water ballet, singers, and dancers with diving champions of Europe, Canada, and America. They arrived in Portland from the Brussels World's Fair to perform August 1 through August 14, 1959. (Courtesy authors.)

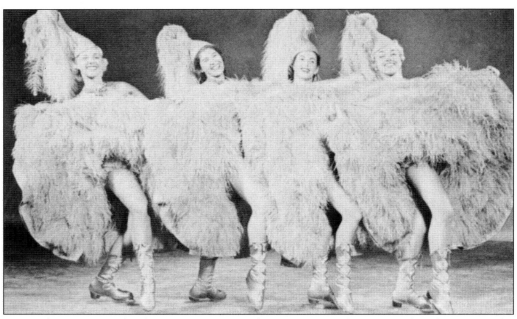

Yet another act featured at the Oregon Centennial Exposition was the Ice Capades. The Ice Capades performers opened the new 9,000-seat arena with an "all-new" show of "beauty, fun and precision skating." The Ice Capades ran from June 11 through June 24, 1959. (Courtesy authors.)

The Oregon Centennial Exposition included the Aqua Theatre at Lake Oswego. This photograph shows boat races held as a part of Aqua Theatre. The activities at Lake Oswego included a Limited Hydroplane Regatta with $600 prize money and a special Rose Festival Marine Day on June 14, 1959, with boats, races, and water-skiing. (Courtesy authors.)

Aqua Theatre included many water-skiing events, such as the Lake Oswego Ski Follies, shown in this photograph. The Ski Follies was "a nationally famed show of utmost beauty and color under the spot lights." Featured were champion water-skiing stars from Cypress Gardens, Florida, including barefoot skiers. (Courtesy authors.)

BIBLIOGRAPHY

Abbott, Carl. *Portland: Gateway to the Northwest.* Tarzana, CA: American Historical Press, 1997.

Abbott, Carl. *Portland: Planning, Politics, and Growth in a Twentieth-Century City.* Lincoln, NE: University of Nebraska Press, 1983.

Alborn, Denise M. "Crimping and Shanghaiing on the Columbia River." *Oregon Historical Quarterly*, Volume 93, Number 3, (fall 1992): 262–291.

www.beadee.com/kaiser/books/swan_shiplist.htm

cinematreasures.org/theater/

Cole's Directory, Portland, Oregon. Lincoln, NE: Cole Information Services, 1991–2007.

Coman, Edwin T., and Helen M. Gibbs. *Time, Tide & Timber, Over a Century of Pope & Talbot.* Pope and Talbot, Inc., 1978.

Dodds, Linda, and Carolyn Buan. *Portland, Then and Now.* San Diego, CA: Thunder Bay Press, 2001.

Dunn, Catherine Baldwin. *Making the Most of the Best.* Portland, OR: Willamette Industries, Inc., 1994.

Durr, Kenneth D., and Philip Cantelon. *Never Stand Still, a History of CNF Transportation, Inc.* Rockville, MD: Montrose Press, 1999.

Fortner, Walter. *Portland.* Charleston, SC: Arcadia Publishing, 2007.

Houlihan, James. *Western Shipbuilders in World War II.* Oakland, CA: Shipbuilding Review Publishing Association, 1945.

Ingraham, Aukjen T. "Weinhard & Portland's City Brewery." *Oregon Historical Quarterly*, Volume 102, Number 2, (2001): 180–195.

Johnson, Brian K., and Don Porth. *Portland Fire and Rescue.* Charleston, SC: Arcadia Publishing, 2007.

King, Bart. *An Architectural Guidebook to Portland.* 2nd ed. Corvallis, OR: Oregon State University Press, 2007.

Martin, Mary L., and Kirby Brumfield. *Greetings From Portland.* Atglen, PA: Schiffer Publishing , Ltd., 2007.

Nelson, Donald R. *Progressive Portland II—Stop and Go.* Portland, OR: self-published, 2006.

O'Donnell, Terence, and Thomas Vaughan. *Portland: A Historical Sketch and Guide.* Portland, OR: Oregon Historical Society, 1976.

Official Souvenir Program, Oregon Centennial 1959. Portland, OR: Oregon Centennial Commission, 1959.

www.pdc.us/pdf/about/portland-ura-history_11-05.pdf

www.pdx.edu/usp/interview_dsterling.html

www.pdxhistory.com/

www.platial.com/tinzeroes/map/2221#post41360

Portland, Oregon City Directory. Kansas City, MO: R. L. Polk and Company, 1901–1985.

Price, Larry W., ed. *Portland's Changing Landscape.* Portland, OR: Portland State University Press, 1987.

www.pstos/org/history

Stanford, Phil. *Portland Confidential, Sex, Crime, and Corruption in the Rose City.* Portland, OR: WestWinds Press, 2004.

Stein, Harry, Kathleen Ryan, and Mark Beach. *Portland: A Pictorial History.* Virginia Beach, VA: The Donning Company, 1980.

stumptownconfidential.com

Taylor, Samuel W. *Line Haul, the Story of Pacific Intermountain Express.* San Francisco, CA: Filmer Publishing Company, 1959.

Thompson, Richard. *Portland's Streetcars.* Charleston, SC: Arcadia Publishing, 2006.

www.venerableproperties.com

ACROSS AMERICA, PEOPLE ARE DISCOVERING SOMETHING WONDERFUL. *THEIR HERITAGE.*

Arcadia Publishing is the leading local history publisher in the United States. With more than 4,000 titles in print and hundreds of new titles released every year, Arcadia has extensive specialized experience chronicling the history of communities and celebrating America's hidden stories, bringing to life the people, places, and events from the past. To discover the history of other communities across the nation, please visit:

www.arcadiapublishing.com

Customized search tools allow you to find regional history books about the town where you grew up, the cities where your friends and family live, the town where your parents met, or even that retirement spot you've been dreaming about.